New Forums: Art Museums & Communities

New Forums: Art Museums and Communities

Source Note
This book is based on interviews with staff, directors, trustees, artists, program participants, and community partners in the 11 museums in the Program for Art Museums and Communities. We reviewed summaries and notes from the group's annual forums. Before each forum, project directors prepared short reports for their colleagues in response to questions we posed with this book in mind. Other sources included evaluation reports, interim and final reports to The Pew Charitable Trusts, museum publications and other project documentation, and e-mail correspondence and follow-up conversations with project directors. All quotations in the text are drawn from these sources.

Design: LevineRiederer Design

Library of Congress Cataloging-in-Publication Data

Pitman, Bonnie.
 New forums: art museums and communities / Bonnie Pitman and Ellen Hirzy.
 p. cm.
 Includes index.
 Summary: Report on experimental art museum community outreach programs funded from 1995-2002 by the Pew Charitable Trusts.
 ISBN 0-931201-89-6
 1. Art museums—Educational aspects—United States—Case studies. I. Hirzy, Ellen Cochran. II. Pew Charitable Trusts. III. Title.
N510.P57 2004
708.13'09'0511—dc22

2004005830

New Forums: Art Museums & Communities

BONNIE PITMAN AND ELLEN HIRZY

AMERICAN ASSOCIATION OF MUSEUMS

This book was generously funded by The Pew Charitable Trusts, which serves the public interest by providing information, policy solutions, and support for civic life. Based in Philadelphia, with an office in Washington, D.C., the Trusts make investments to provide organizations and citizens with fact-based research and practical solutions on challenging issues. With approximately $4.1 billion in dedicated assets, in 2003 the Trusts committed more than $143 million to 151 nonprofit organizations.

The opinions expressed in this publication are those of the authors and do not necessarily reflect the views of The Pew Charitable Trusts.

Contents

ACKNOWLEDGMENTS ix

PREFACE BY MARIAN GODFREY, 1
Director, Civic Life Initiatives, The Pew Charitable Trusts

ART MUSEUMS IN TRANSFORMATION 7

BUILDING FROM STRENGTH 18
Behind the Lions, Families Are Welcome: Art Institute of Chicago 22
A Renewed Vision: Isabella Stewart Gardner Museum 32
More than a Museum: Walker Art Center 42
A Museum in the Mood for Change: Carnegie Museum of Art 52
A Valued Resource for Educators: Seattle Art Museum 64
Inviting Student Engagement: 76
University of California, Berkeley Art Museum and Pacific Film Archive

NEW AUDIENCES, NEW DIRECTIONS 86
Art Across Borders: Museum of Contemporary Art San Diego 90
Creative Harmony: Museum of Art, Rhode Island School of Design 100
A New Audience for a New Century: Minneapolis Institute of Arts 110
A Family Focus That's Built to Last: Denver Art Museum 118
A Place of Their Own: Whitney Museum of American Art 130

TRANSFORMATIVE MOMENTS 141

PROGRAM FOR ART MUSEUMS AND COMMUNITIES
PARTICIPANTS 145

THE AUTHORS 159

INDEX 161

Acknowledgments

*N*ew Forums: Art Museums and Communities represents the accomplishments of The Pew Charitable Trusts Program for Art Museums and Communities (PAMC). The museums that participated in the program are deeply committed to enhancing experiences and dialogue about creativity, art, and artists and to changing their relationship with their communities. These museums' transformations are recorded in this book and represent some of the most inventive and creative work they have undertaken.

I would like to gratefully acknowledge the extraordinary support and vision of Marian Godfrey, director, civic life initiatives, at The Pew Charitable Trusts. Her commitment to supporting this initiative and her dedication to excellence and service have inspired these projects and each of the participants. I would also like to thank the Trusts' board of directors as well as Rebecca Rimel, president and CEO, for funding this project and for supporting technical assistance, the annual forums, and this book. Thanks to their recognition of the initiative's importance, these stories and lessons can be shared with others in the museum community for years to come.

New Forums represents the collective accomplishments of the staff and boards of the 11 participating organizations. Implementation of the PAMC projects occurred through the outstanding leadership of the project directors and with the support of the museum directors. Over the years that we worked together, the group forged friendships and developed an openness and trust that enabled honest sharing of successes and problems. The thoughtful conversations stimulated deeper understanding of the issues, encouraged risk taking, and enriched the quality of the projects.

Countless individuals assisted with the projects over the years. To all the directors, educators, curators, and other staff, I extend my deep gratitude for their excellent work and support for the Program for Art Museums and Communities. It was an incredible journey that required the contributions of

many individuals. The following museum professionals helped Ellen Hirzy and me with the many interviews and reviews of texts that were required to prepare this manuscript:

- ◆ Art Institute of Chicago: Jean Sousa, director of interpretive exhibitions and family programs; James Wood, president and director
- ◆ Carnegie Museum of Art: Marilyn M. Russell, curator of education; Richard Armstrong, Henry J. Heinz II director
- ◆ Denver Art Museum: Patterson Williams, co-dean of education and master teacher for Asian and textile art; Melora McDermott-Lewis, co-dean of education and master teacher for European and American art; Lewis Sharp, director
- ◆ Isabella Stewart Gardner Museum: Margaret K. Burchenal, curator of education and public programs; Anne Hawley, Norma Jean Calderwood director
- ◆ Minneapolis Institute of Arts: Kathryn C. Johnson, chair, education division
- ◆ Museum of Art, Rhode Island School of Design: David Henry, head of museum education
- ◆ Museum of Contemporary Art, San Diego: Anne Farrell, director of external affairs; Hugh M. Davies, David C. Copley director
- ◆ Seattle Art Museum: Jill Rullkoetter, Kayla Skinner director of education and public programs
- ◆ University of California, Berkeley Art Museum and Pacific Film Archives: Stephen Gong, associate director
- ◆ Walker Art Center: Howard Oransky, director of planning; Sarah Schultz, director of education and community programs; Kathy Halbreich, director
- ◆ Whitney Museum of American Art: Helena Vidal, assistant director of education

Over eight years, project directors, museum directors, and other staff gathered to discuss their projects and the issues they were facing. Catherine McEver documented four of the annual forums, collecting the creative ideas and discussion in an accurate yet lively way. Her notes helped us write this book. Inge-Lise Eckmann Lane conducted additional research, interviews, and site visits to the museums, offering both primary source material and her own insights.

Ellen Hirzy and I collaborated on all aspects of this book. Her commitment to the museums helped to guide the development of the publication. Ellen attended the forums over the years and conducted site visits and interviews, and her clarity of writing and thinking are evident in the final product. Over the years, her support has been greatly appreciated, and her excellent contributions helped make this book a reality.

At the American Association of Museums, Jane Lusaka, assistant director of publications, and John Strand, director of publications, supported this project and were instrumental in directing the publication's final phase.

I would also like to acknowledge the three museums I served during my tenure as a consultant for the Program for Art Museums and Communities: the University of California, Berkeley Art Museum and Pacific Film Archives; the Bay Area Discovery Museum; and the Dallas Museum of Art. In particular, I would like to acknowledge Jack Lane, the Eugene McDermott director of the Dallas Museum of Art, for his thoughtful support and encouragement during the years this book was being written.

New Forums: Art Museums and Communities is dedicated to my son David Gelles, who spent countless hours in museums as a child and is now beginning his own career in the field. David's support and enthusiasm for my work gave me the courage to complete this project.

Bonnie Pitman
Project Director, Program for Art Museums and Communities
Deputy Director, Dallas Museum of Art
March 2004

Preface

The Program for Art Museums and Communities (PAMC) is the product of many influences and ideas that converged at a particular place and time to shape a museum initiative that has achieved spectacular success. Developed during the early 1990s and implemented in the years 1995 through 2002 via a series of grants from The Pew Charitable Trusts, the program has helped participating museums meet or surpass significant and wide-ranging goals for institutional change. With this publication, which outlines the objectives, strategies, and results of the program, I believe that the Trusts' broadest, most ambitious goal for the program also can be met. Other museums will be able to take advantage of the learning and experience of PAMC participants and, I hope, will be encouraged to embark or continue on their own course of institutional change on behalf of their communities.

The story began in 1990, when The Pew Charitable Trusts launched a national initiative to support arts institutions that were creating programming to strengthen their relationships with artists and their public constituencies. Our goal was both to broaden public participation in the arts and to enhance the quality of the arts experience for participants—especially by drawing artists back into the center of the institutional enterprise. We pursued a series of artist-residency programs in theater, music, and dance, and supported numerous organizations and programs that expanded audience access to a diverse array of artistic activities. In seeking to extend the initiative to include museums, we began by considering a program of artist residencies in art museums, as a means of further enlivening these institutions as well as opening their doors more widely to the general public.

Simultaneously, the American Association of Museums convened a National Task Force on Museum Education, which ultimately produced the report *Excellence and Equity: Education and the Public Dimension of Museums*. I had the privilege of participating on the Task Force, which provided me with a much-needed tutorial on the museum field's various and sometimes conflict-

ing roles and needs—particularly regarding museums' stewardship and education responsibilities. *Excellence and Equity* reaffirmed my belief that investments in artistic development and quality can go hand in hand with a commitment to expanding public engagement. In fact the two must be mutually reinforcing if arts institutions are to thrive and to fulfill their public trust.

In the early 1990s the idea of expanding public participation in the arts, influenced by the ups and downs of extended historical cycles, was in the ascendant, as it continues to be today. The Trusts clearly benefited from the learning generated by successes and failures of previous efforts. Earlier initiatives, especially the major investments in the art museum field by the Wallace Foundation (then known as the Lila Wallace-Readers Digest Fund), had laid an invaluable groundwork of experience, preparation, and readiness in some museums to take the next steps in institutional transformation. Thus, PAMC was able to build upon previous progress by museums and help the field advance along a pathway already marked out by others.

It is characteristic of The Pew Charitable Trusts to invest where ideas or issues are ripe and significant progress can be made within a reasonable time. Thus, before we developed PAMC, we turned to research, including *Excellence and Equity*, to identify key needs in the art museum field, then consulted with field leaders to determine what strategies for positive change might have the best likelihood of success. The first critically important step was to connect in late 1993 with Bonnie Pitman, then deputy director of the University of California, Berkeley Art Museum and Pacific Film Archives, and chair of the *Excellence and Equity* task force. Bonnie became our partner and guide in the development and implementation of PAMC. Under her leadership, the Trusts convened two advisory groups of distinguished art museum directors in early 1994, one in Philadelphia and the other in Berkeley. Based on their guidance and strong recommendation (to my temporary chagrin) against focusing an initiative specifically on artist-residency projects, the Program for Art Museums and Communities took shape.

The board of The Pew Charitable Trusts approved the concept for PAMC in June 1994, and the first grants to museums were made in June 1995. Over a four-year period grants were made to a total of 12 museums (one subsequently withdrew from the program). Because project periods extended for up to

four years, activities in some museums continued through 2002, so that the lifetime of PAMC was eight years. The Trusts also provided support for communications and technical assistance for program participants—as well as for the writing of this book by Bonnie Pitman and Ellen Hirzy—through two grants to the Bay Area Discovery Museum, where Bonnie served as director from 1995 to 2000. Work on the PAMC program and the book has continued during Bonnie's tenure (beginning in 2000) at the Dallas Museum of Art, which is where the final forums took place.

PAMC was designed to test models for innovative programming that would both increase the participation and engagement of public audiences in art museums and rebuild community loyalty and support. At the heart of the program was the assumption that to accomplish these objectives, museums needed to push beyond the development of individual projects and achieve fundamental change in their operational approaches to program development and community interaction. And indeed, as described in detail throughout this book, the participating museums' greatest and most long-lasting accomplishments have come through transformation of the processes guiding both internal and external interactions among museum staff and public constituencies. In some instances, the very vision and mission of the museums have evolved as a result of their participation in the Program for Art Museums and Communities.

Several specific aspects of PAMC's design drove its success. Key among them were the length of each project period (usually three to four years), the substantial size of support, and the flexibility given to each museum to revise its project on an ongoing basis in response to learning and circumstances. By providing enough time, resources, and flexibility, the program allowed museums to experience what it actually means to institutionalize change. Even more important was the creation of a mechanism for communications and technical assistance for participating museums, designed both to ensure positive results in individual projects and embed learning and program achievements in the art museum community. Under Bonnie Pitman's leadership, project directors met annually, joined in some years by museum directors and other speakers. The sharing of lessons learned among project participants and the support, challenges, critique, and community they provided to one another were of incalculable importance in furthering the successes of both individual museum projects and the program as a whole.

This book is the final product of the Program for Art Museums and Communities, particularly its communications and technical assistance components. For it, and for shepherding the program through to its conclusion with unflagging energy, intelligence, passion, and humor, The Pew Charitable Trusts and I owe a great debt of gratitude to Bonnie Pitman. Our thanks go also to the Bay Area Discovery Museum for administering the communications component of the program; to Ellen Hirzy, coauthor of this book; and to the American Association of Museums, whose decision to publish it ensures that it will become a resource for the broader museum community. And finally, our deepest thanks to the directors, project directors, and project staff of the participating museums who have collectively become such a great and heartening force for transformational change. We salute you.

Marian A. Godfrey
Director, Civic Life Initiatives
The Pew Charitable Trusts
January 2004

Art Museums in Transformation

A new and imaginative 21st-century museum environment is taking shape in America. Surrounded by some of the most diverse neighborhoods in Minneapolis, the Walker Art Center's open and inviting new building is designed to be closer to a forum and a town square than a traditional museum, more an experience than a place. Boston's 100-year-old Isabella Stewart Gardner Museum has shed its image as a 19th-century time capsule to become a lively cultural center for visitors of all ages. All over the country, art museums are becoming forums for the discussion of new and productive ideas, places where artists, scholars, and the public can interact and learn from one another in meaningful ways as they experience the arts. This transformation is taking place across the museum field as part of a movement to expand the vision of museums' purpose and possibilities and connect them with their communities.

As real and virtual destinations, museums are becoming less event-driven and more focused on providing opportunities for discovery, involvement, and imaginative response. They invite contemplation and celebration, offering experiences with works of art that range from serene and intimate to spirited and communal. They are places where people learn individually or in groups, and they are leisure and entertainment options that provide memorable personal experiences. A museum's assets—collections, exhibitions, staff, and buildings—provide extraordinary possibilities for supporting a deeper and richer service to the public. Like the forums of ancient Rome, museums are places where communities gather to learn, debate, share experiences, socialize, and be entertained. They no longer simply present objects; they actively engage their audiences in experiences in looking at art, and they are places where artists, scholars, and the public engage in learning and can be challenged by new ideas and images. In art museums, the fundamental connection between art and people is at the heart of this change. Engagement with art can provide exposure to or increase understanding of creativity, history, and cultures, or it can explore difficult issues and events. Still, even some of the most

innovative art museums are challenged by the perception that they are remote institutions designed solely for people who are knowledgeable about art.

This book shares the stories of exploration, action, and ultimately transformation in a diverse group of 11 art museums. Supported by up to four years of funding from The Pew Charitable Trusts Program for Art Museums and Communities, these museums pursued stronger connections to their communities through experiences with art and artists. In working toward a visitor-centered vision, they aimed for sustained engagement rather than short-term interest. With their focused initiatives, they created infrastructures for successful visitor experiences. Long-term funding was a critical part of the process. The Pew funds allowed the museums to experiment, a rare luxury in the usually hectic operating climate of the nonprofit world. Receiving this support from 1995 to 2002, the museums were able to test and refine approaches and programs, which in most cases were incorporated into operating plans and budgets. Some initiatives led to the development of endowments; other initiatives have permanent physical spaces; and others are now part of the museum's core program.

The Program for Art Museums and Communities arose from the core principles of *Excellence and Equity: Education and the Public Dimension of Museums*, the 1992 report by the American Association of Museums that emphasized the importance of working with collections *and* the public. The *Excellence and Equity* mandate encouraged support for public service in all facets of the museum—from mission to programs to services—and emphasized the need to involve board, staff, and volunteers. The concept was a simple one, but the implementation required the convergence of a complex set of circumstances, including leadership to create change, resources to implement change, and time to assess its effectiveness.

The Pew program encouraged art museums to think creatively about enhancing the quality of the visitor experience and expanding service to their communities. The museums began with the intent to create programs that strengthened partnerships, heightened community visibility, and extended service to a broader audience. Over time they found that to be a reliable, accessible bridge between people and art, they had to change how visitors experience art in a museum setting, focusing on how to guide that experience and

how to sustain it. "Audience engagement is moving away from abstraction," says Walker Art Center Director Kathy Halbreich. "To serve multiple audiences and multiple learning styles, museums need to provide a network of links for engaging people. It's no longer a linear process."

Participating in the PAMC project were:

◆ ART INSTITUTE OF CHICAGO, which expanded its programs and services for family visitors and, in the process, improved internal communication among the staff.

◆ CARNEGIE MUSEUM OF ART, which experienced a significant shift in board and staff attitudes toward community involvement.

◆ DENVER ART MUSEUM, which intensified its focus on family learning, invested in innovative programs and materials developed a relationship with the neighboring Denver Public Library.

◆ ISABELLA STEWART GARDNER MUSEUM, which inspired new community interest through artist residencies and school partnerships.

◆ MINNEAPOLIS INSTITUTE OF ARTS, whose board and staff infused the museum with a customer-oriented focus, creating a more inviting place to visit.

◆ MUSEUM OF CONTEMPORARY ART SAN DIEGO, which, with equal emphasis on art and community, defined its core vision for engaging its San Diego-Tijuana border community.

◆ MUSEUM OF ART, RHODE ISLAND SCHOOL OF DESIGN, which gained a new community presence by partnering with the Providence Public Library and inviting artists to create works in library branches, in full public view.

◆ SEATTLE ART MUSEUM, which responded to the serious decline in art education in local schools by creating significant new educational resources students and teachers.

◆ UNIVERSITY OF CALIFORNIA, BERKELEY ART MUSEUM AND PACIFIC FILM ARCHIVE, which dedicated resources to reaching out to the transient student audience and changing students' and faculty's perceptions of the museum.

◆ WALKER ART CENTER, which developed interdisciplinary artist residencies in partnership with community organizations and thus brought the museum closer to its own neighborhood.

◆ WHITNEY MUSEUM OF AMERICAN ART, which began an intensive initiative to engage teens in the life of the museum through intergenerational programs that extend the museum's impact.

Each of these museums is a product of its context—size, location, mission, audience, and founder's vision. Though the routes they took were different, all sought to learn more about that context. And all were committed to becoming institutions where learning, flexibility, and change are integral and valued parts of the organizational culture. Ultimately, there was a transformation in each museum's philosophy and practice, including the activities that shape the visitor's experience, creative working cultures that support experimentation, and flexible approaches to community alliances. In the process, the museums' dual dedication to their collections and the public was revitalized.

A VISITOR-CENTERED FOCUS

Experience suggests that to engage an audience successfully, the museum must do more than set goals and develop programs. It must integrate a comprehensive visitor focus at every level of the institution and within its vision and identity. Adopting visitor-centered values means communicating clearly that the museum is accessible, reliable, and responsive to the people who visit and those who would like to feel more welcome. It means addressing the question that Marnie Burke de Guzman of the Berkeley Art Museum posed for her colleagues: "How do we treat our audiences as a precious commodity, as precious as a work of art, as precious as an artistic experience?"

Many of the museums wrote new mission statements, developed strategic plans that make visitor focus a priority, and conducted extensive audience research. They launched permanent programs linked to the collections, involved artists-in-residence in creative ways, and established community linkages. Richard Armstrong, Henry J. Heinz II director of the Carnegie Museum of Art, observes that his "under-examined, un-self-conscious institution" was "turned . . . upside down and inside out. . . . We began to engage the public in ways we had not done before."

Knowing the audience's perceptions and motivations was critical to achieving a visitor-centered focus. This meant learning more about the community, the institution's potential impact, and the characteristics of visitors the museum wanted to engage. Extensive audience-research projects helped define strategies and motivate changes. Some institutions identified target audiences—

families, students and educators, teens, and communities and neighbor-hoods—that expanded their visitor focus and shaped the direction of their approaches and programs. Engaging families, for example, required looking at the nature of the museum environment, which tends to be designed for adults. Students and educators respond best to small-group projects with a concentrated impact on learning. Teens required small-scale programs that emphasize quality, depth, and the life-changing potential of art.

The museums also were committed to using their collections to engage visitors, though the ways this occurred were as diverse as the institutions and the audiences they sought to reach. The collections themselves are strikingly different—from the encyclopedic holdings of the Art Institute of Chicago to the focused, specialized collections at the Museum of Contemporary Art San Diego. Because collections are open to ever-changing approaches, interpretations, and learning opportunities, there is no single pathway to interaction with the objects. Instead, the museums took on the challenge of making art approachable from multiple directions, with the institution providing the bridge through its exhibitions and programs, the knowledge and expertise of its staff, and the creative contributions of working artists. In the course of the Gardner Museum's work with teachers, says Curator of Education Margaret K. (Peggy) Burchenal, the teachers came to see that "behind these beautiful paintings are windows into a world that has issues that are common to our world. Museums need to keep telling people about those connections, making the opportunities for engagement clear."

Six museums used artist-in-residence programs as a key to focusing on the visitor experience and building bridges to new segments of the community. Artists engaged the public, provided new perspectives on permanent collections, added works of art to the collection, and created exhibitions that offered new insights into contemporary art. In turn, the museums provided a place and a support system for the creative process and for communication and exchange. Anne Hawley, Norma Jean Calderwood director of the Gardner Museum, observes that artists-in-residence "brought the Gardner to life with vigor unmatched since the lifetime of the founder." Sarah Schultz, director of education and community programs at the Walker Art Center, says the staff learned that "people who have intensive experiences in artist residency programs have a much better understanding of the creative process and . . . a

much better feeling about a continuing relationship with the Walker." Still, community-oriented artist-in-residence programs can be difficult to accomplish, as they require balancing sometimes-competing interests. The artist, for example, may be most concerned with the creative process, while the museum may be most interested in engaging the public in that process.

Technology was an evolving resource for all the museums in the program, which began in 1995 when only a few of the museums were wired. Today, interactive technology in different formats is a critical element that provides enhanced learning resources and documents the ongoing work the museums began with their Pew initiatives. At the Museum of Contemporary Art San Diego, for example, artist interviews are part of a bilingual handheld audio guide to the collection. Documentary videos of artists-in-residence archived on the RISD Museum of Art's Art ConText Web site are an open and honest record of successes and challenges. The Whitney Museum's Youth2Youth Web site is a dynamic site designed by teens for teens, with "talk back" features, bulletin boards, biographies of program participants, and news of museum events. The online (and in-person) Teacher Resource Center developed by the Seattle Art Museum is a mainstay of the museum's commitment to professional development for educators.

CREATIVE CULTURES AND ORGANIZATIONAL CHANGE

To differing degrees and at different rates, the museums are transforming themselves from risk-averse and slow-to-adapt institutions to creative environments that foster innovation and change and take a visitor-centered approach to doing business. The museums' core values have taken on what Richard Armstrong calls an "extroverted" focus, leading to some profound changes in organizational behavior. Instead of acting solely as service providers, the institutions now work with the community for the benefit of the public. Organizational communication patterns—among the staff and between staff and board—also have changed for the better.

These art museums looked at multiple ways they could integrate visitor-centered values into programs, experiences, services, and spaces. They tried different communication patterns and were gratified by the results. They re-

evaluated organizational structures, created new staff positions, and experimented with programs and services. All these changes become part of the institutional structure and were incorporated into mission and future plans. Visitor-centered attitudes are integral to the planning of new buildings and galleries. The museums' work is cumulative, and their staffs would agree unanimously that it is not yet complete.

In many cases, the museums' boards are providing the vision, leadership, and resources to make these changes happen. Other factors include empowering staff at different levels of the museum to implement change and create new organizational structures; establishing an internal communication process that facilitates shared goals; and developing an ongoing assessment that enables the staff to test and modify programs and practices. In every museum, directors, deputy directors, educators, curators, artists, and marketing and communication specialists brought their own individual leadership styles and qualities to the project, including:

◆ clearly articulated vision and values

◆ investment of personal energy and enthusiasm

◆ trust, confidence, and support for risk taking

◆ celebration of accomplishments

◆ commitment of time and energy to educating staff and board and gaining their support for visitor-centered values

◆ willingness to dedicate resources and commit the institution to ensuring the sustainability of visitor-centered vision and practices

Some participating museums created "community liaison" or "community relations" staff positions, usually within the education department, thus placing the responsibility for serving a new audience squarely within the realm of education and public programs. The Art Institute of Chicago and the Seattle Art Museum saw community engagement as a museum-wide responsibility and placed the community liaison function in the director's office. The Berkeley Art Museum and Pacific Film Archive created the position of academic liaison to attract faculty interested in accessing the collections, exhibitions, and building for teaching purposes.

Efforts at community engagement led to—and sometimes required—positive changes in communication, which in some cases were long overdue. Communication and team building were frequent discussion topics among project directors, who saw them as a persistent challenge. But by the conclusion of the program, they reported greater flexibility, honesty, and receptiveness to diverse points of view across the museum. In fact, many initiatives were successful because of the way staff members communicated with each other. Whether through meetings, e-mail, or casual communication, the museums realized that it was important to repeat core messages and encourage ideas to germinate through staff interaction. Something as simple as a regular interdepartmental staff meeting focusing on visitor service made an enormous difference.

Open communication helped create a safe environment for creative problem solving and risk taking. Staff members felt comfortable enough to agree to disagree, to learn from each other, to state differences, and to be honest. "If there is one ingredient that needs to be present in a healthy organization," says Kathryn Johnson, chair of the education division, Minneapolis Institute of Arts, "and it has to come from the top, it is the creation of a safe environment in which to take risks. If people don't want to come to meetings or don't want to talk in meetings, part of it is because they [are afraid to] say what's really on their mind."

Embracing the potential inherent in new ideas was a key attribute in many of the museums. This focus on experimentation, like R&D in a business setting, encourages greater creativity. Ideas can be generated, tested, refined, learned from, and evaluated. A learning environment also reinforces what works well and supports ongoing change. "In some ways institutional change is analogous to how we as individuals manage to change," says Stephen Gong, assistant director of the Berkeley Art Museum. "It's a backwards and forwards process, and sometimes it takes time for you to realize what has transformed."

Much has been written about partnerships between museums and community-based organizations and what contributes to their success or failure. Relationships based on mutual interest, parallel goals, clear expectations, and collaborative decision-making have the best chance at success, but there are no set formulas. Each of the museums had established some form of community relationship, so partnerships were not a new concept. The challenge was to capture the potential of those partnerships by deepening and expanding the relationships between visitors and the museum. Many of the museums initially described their project goals in terms of partnerships with schools, universities, libraries, and other community organizations. Over time, those partnerships became not ends in themselves, but important ways of making the museum a more welcoming and accessible place and enhancing the quality of the visitor experience.

The museums sought compatible organizations as partners, developed shared goals, and had commitment from all levels of both organizations. Solid groundwork, a commitment to experimentation, assessment, and revision, open communication, and productive personal relationships help sustain and enhance the alliances. The museums confirmed the simple truth that building and sustaining a solid relationship takes time. Most of the partnerships established during the Pew program are in many ways just beginning. As Robert W. Eskridge, executive director of museum education at the Art Institute of Chicago, explains, the nature of the Pew initiative "predisposed us to be open to opportunities that we wouldn't have anticipated were there."

MOVING FORWARD

Simple, consistent actions—rather than dramatic steps or major upheavals—transformed the museums. Each institution had a working environment that supported change. More important, museum leadership at the board, director, and staff levels was willing to take risks and eager to share experiences, successful and otherwise, with colleagues.

Change resonates throughout the museums:

◆ Revised mission statements reflect an outward-looking emphasis on visitors and communities. Strategic plans incorporate goals and strategies for excellence in the artistic program and audience engagement.

◆ Permanent spaces and resources—including family centers, gallery activities, print and audio guides to the collection, and interactive materials—make engaging with the collection comfortable and rewarding.

◆ New staff positions and organizational structures introduce new perspectives and increase the museum's capacity for satisfying visitors. Staff training and communication stress meeting visitors' needs.

◆ New programs and program formats, including artist residencies, reflect visitor-centered goals.

◆ Community alliances help reach neighbors and people who do not traditionally visit the museums.

◆ New audiences, especially families and teens, help shape program formats, museum spaces, and staff attitudes toward visitors.

◆ Technology aided efforts at communication, information sharing, and public access.

◆ Funding from new endowments or from annual operating budgets is sustaining the programs started as Pew-funded initiatives.

◆ In planning for expansion, the visitor experience is of strategic importance.

As the museums sought to strengthen their community relationships, mostly by establishing alliances or reaching underserved audiences, an interesting transformation occurred. They found that if they wanted to serve as a reliable, accessible bridge between people and art, they needed to change their perception of how people experience art in the museum, as well as how they guide and sustain that experience. They were reminded of some essential questions that are common to all museums: What brings people to a museum? What keeps them away? What inspires them to consider art a vital part of their lives? How can a museum be a better family place, a more appealing option for students or a more useful resource for teachers? How can it be simultaneously a community place and a destination for visitors from around the world? How can it translate the idealistic language of its mission into concrete, meaningful, and pleasurable experiences for more people? As the museums formed alliances, involved artists, and pursued new and expanded audiences, these

questions were at the core of their efforts. The most intriguing and beneficial lessons centered on process, not product, on the culture of the museum and its approach to the visitor, not programs. Adopting a museum-wide visitor-centered attitude was a powerful outcome.

The museum profiles in this book illustrate and elaborate on an agenda for change that is a driving force in all 21st-century museums. These institutions are fortunate to have inspired leadership and sound management practices, and their boards and staff share the belief that systemic creativity is the mark of a healthy organization. They have experienced the impact of the new, and they understand the importance of allocating enough time to integrate the consequences of change into structures, processes, and facilities. They know that community relationships are not about delivering a product. They are about human interactions and experiences with works of art that have real and lasting value.

Building from Strength

By strengthening core programs with enriched opportunities for their visitors, the six art museums profiled in this section determined ways to capitalize on and extend their existing work. They identified varied audiences, including students, educators, university students, families, and people who live in their neighborhoods. Every museum was transformed by its experiences with creating new programs and engaging new audiences. One approach was to involve audiences in existing programs, such as artist residencies. Another was to identify an audience—such as families, educators, or students—and expand programs and services for them.

The Art Institute of Chicago's tradition of serving families was primarily confined to programs and exhibitions in the Kraft Education Center. Research studies indicated that if the museum wanted to diversify its audiences, involving families would be an important strategy. The museum also knew that parents wanted to learn how to have satisfying museum visits with their children. A new series of programs and resources for parents and children focuses on interactive learning about the collections.

The Isabella Stewart Gardner Museum linked its successful interdisciplinary artist-residency program to neighborhood schools, over time engaging educators, students, and parents in the museum. The residencies yielded exhibitions that enliven the collection and provoked dialogue with visitors. Educators involved in training programs focused on the collection and developed new ways to interpret it into the curriculum. These initiatives have led to a lively museum that is fully a part of its neighborhood.

Artist residencies have been a core component of the Walker Art Center for many years, but they were focused primarily on presenting. The museum wanted to reach out to people who live in the surrounding neighborhoods, and the staff decided artist residencies would be an ideal vehicle. The museum sought out community-based partners and artists who were willing to fully engage the community in their creative process.

The Carnegie Museum of Art conducted extensive research to understand the perception of the museum in the community. The studies were shared with staff and board and led to efforts to reach into the community through libraries and schools. As a result, the museum has a new emphasis on visitors, accompanied by changes in staff, board, planning processes, exhibition planning, program development, and marketing that emphasize its "extroverted" role.

The Seattle Art Museum always has provided extensive services to students and educators, but it wanted to enrich and strengthen these services through school partnerships, curriculum development, and rigorous evaluation. The creation of the Ann P. Wyckoff Teacher Resource Center—a virtual and physical hub for professional development and educational resources—is perhaps the most significant outcome.

The University of California, Berkeley Art Museum and Pacific Film Archive has been serving university students since its founding, but it wanted to increase the size of that audience and with new types of programs. Seeking to define itself as a creative and an educational place, the museum added new programs, such as artist residencies, to involve students and link to university courses. The museum gained a deeper understanding of how to work with university students and faculty to effect long-term change in engagement and involvement.

Behind the Lions, Families Are Welcome

ART INSTITUTE OF CHICAGO

The Art Institute of Chicago easily attracts 1.5 million visitors a year, who come to view one of the world's great collections. Everything about this museum is vast—its building, its audience, the knowledge and significance embodied in the art exhibited there. Memorable museum experiences happen every day at the Art Institute, not just in structured programs, but in those personal moments involving an individual and a work of art that are impossible to quantify or even to explain.

The Art Institute's initiative, Looking at Art Together, focused on helping families with children feel welcome in the museum so that these memorable experiences would be easily available to them. For two decades, the museum and its staff of educators have offered respected programs designed just for adults and kids. Families often make the Kraft Education Center on the ground level their first stop, knowing that they will be able to explore, play, and enjoy art in a comfortable setting where youngsters aren't limited by the "don't touch" atmosphere of an art museum. A selection of workshops, drawing sessions in the galleries, storytelling festivals, and studio programs is always available. In the adjacent Family Room, there is a small library with picture books, puzzles, and games.

With this infrastructure in place, the education staff knew they could do even more. They wanted to encourage families to feel at home anywhere, not just in programs or spaces designed especially for them. Reaching families, they believed, is also a route to building a diverse audience for the future. So what began as an education initiative became a museum-wide exploration of attitudes, behavior, amenities, and programs that seeded a visitor-centered focus on families. This exploration required a change in the way staff members communicate across departments, and it was just as important as the specific programs that Looking at Art Together stimulated. "The sustained effort across

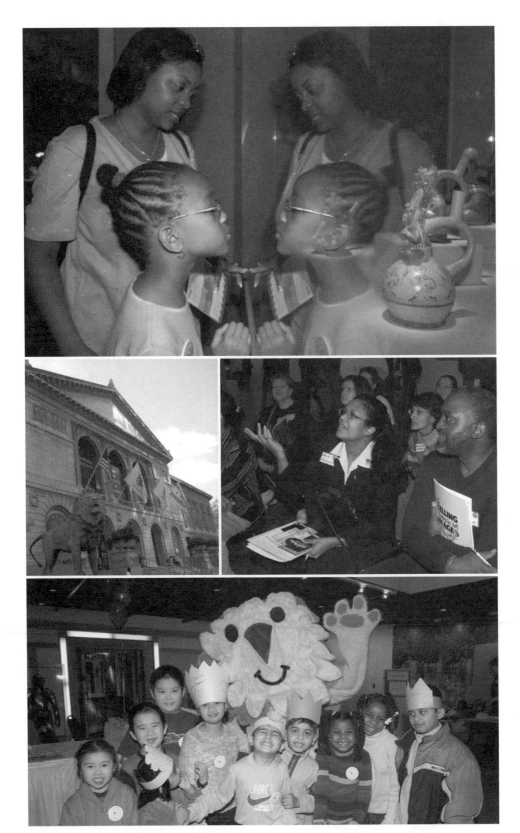

(Clockwise from top) 1. A mother and daughter examine ceramics from ancient South America in the Art Institute's galleries. 2. A participant asks a question at a Parent Workshop. 3. Artie the Lion, the family programs mascot, poses with a group of children during a Behind the Lions event, named for the famous pair of lions that flank the Art Institute's front door (4). ©Art Institute of Chicago.

the institution was incredibly valuable and really transformative," says Robert W. Eskridge, executive director of museum education. "There's nothing like being in a room with colleagues from many different departments and hearing them say the things we would normally be saying in the education department. That's something I just didn't anticipate as an outcome of this project."

James N. Wood, president and director of the Art Institute, explains that the experience ultimately runs even deeper than the family audience. "It strengthened our commitment to encouraging the social aspect of art appreciation. The family was our particular focus, but the ability to share both one's pleasure and one's concerns and even battlement in front of works of art can often be deeply rewarding. Encouraging this communication and helping facilitate it has now been given a higher priority."

New Ways to Communicate

Looking at Art Together centered on Parent Workshops that combined a presentation on child development with a gallery visit in which museum staff explored strategies for looking at and discussing works of art with children. Parents were invited to return with their children for Behind the Lions Family Days, when they could try out what they had learned and enjoy family-oriented art activities. (The name has real meaning for the Art Institute because of the famous pair of lions that have flanked the front door since 1893.) The initiative also included an effort to increase attendance by African-American families by building relationships with community organizations. The annual Kaleidoscope Family Day, a summer event with free admission for families, inaugurates each season of family programming.

The story of Looking at Art Together is one of change and progress in a large museum—incremental and relatively slow. But considering the size and complexity of the institution, it is a success story in part because of the significant changes in communication patterns and practices that have occurred. Staff members at all levels cite improvements in the way they work together as being fundamental to enhancing the family visitor's experience. The dedication to communication begins at the top, where Wood encourages dialogue about management structures, artistic integrity, and the commitment to the civic and societal role of one of the world's great art museums.

The initiative presented a long-overdue opportunity for cross-departmental learning and cooperation. In a large and complex institution, it is not unusual for departments and people to work in isolation. By seeking out colleagues who interact directly with visitors and building new working relationships with them, the family programs staff took steps toward changing this pattern.

Early in the project, the family programs department invited staff and volunteers in the visitor services and volunteer departments to informal orientation sessions. For many participants, these meetings were eye-opening introductions to family programs in general, and especially to the needs and interests of family visitors. An interdepartmental planning team was established, including staff from the museum education, curatorial, visitor services, volunteer, public affairs, marketing, and protection services departments. Team members identified and implemented improvements in staff training, marketing, and the museum facility that would accommodate families. The benefits of improved internal communication filter down to the public. Frontline visitor services personnel have a new understanding of their important role as the visitor's first contact with the museum, and they use what they have learned about family visitors in their daily routines. Security guards are more sensitive to the challenges of parents with children in the galleries. And marketing staff have helped to improve communication about the museum's offerings for families.

"The multiple perspectives we've heard in our team meetings have been extremely valuable," says Jean Sousa, director of interpretive exhibitions and family programs in the museum education department. "Before, we were in our own insular worlds, doing our programs. But now we have a direct relationship with people in other key departments, and we feel that we understand their language, their values, and their priorities—and they understand ours. That allows us to come together and solve problems."

Focusing on families who may not be regular museumgoers has helped staff understand how to welcome novice visitors. "People know they're supposed to come to the Art Institute, but they don't know what they're supposed to do here," says Robert Hudson, associate director of visitor services. Now, visitor services staff and volunteers are more aware of their high-profile responsibility for welcoming people. "Our public contact volunteers are here to make vis-

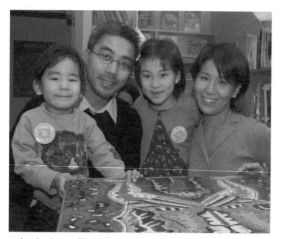

A family shows off a finished puzzle in the Family Room. ©Art Institute of Chicago.

itors feel comfortable. They really set the tone for the visitor's experience," says Michael Mitchell, director of volunteer services. With this initiative, they are learning to view everyone on an equal level," Both groups now know each other, too. "There was a time when visitor services staff worked side by side with volunteers at the museum entrance but had no formal working relationship," says Hudson. "Now we have one, and that's a dramatic difference." Mary Erbach, assistant director, museum education, interpretive exhibitions and family programs, points out that visitors benefit most: "If staff from different departments are communicating about their various agendas, we all get into the habit of thinking first about our visitors and what their needs are."

Interdepartmental communication remains complex in this institution with its staff of nearly 1,000. Visitor services staff turnover is high, so training must be ongoing. Selecting and training volunteers who enjoy working with families is a priority for the volunteer department, and so is diversity. As a result of Looking at Art Together, Mitchell says, "I've realized that the volunteer staff needs to be as racially and demographically diverse as possible. The museum has to show that it's open to everybody." If a volunteer is less than professional with a visitor, Mitchell schedules coaching sessions to work on the problem.

Communication also has changed from the curatorial perspective. Martha Tedeschi, a curator in the Department of Prints and Drawings, says she now feels confident about leading elementary school students through the museum—"something we curators do not usually do. I feel I have a better handle on the spaces, ideas, and methodologies that appeal most to young visitors." The interdepartmental dialogue led her to see family programs staff as a resource when she is working with outside support groups. "This kind of contact between education staff and other museum constituencies will help give greater visibility to the Art Institute as a museum that takes family audiences seriously," she says.

Many parents are reluctant to bring their children to the Art Institute because of their own feeling that they are not knowledgeable enough about art. When parent focus groups confirmed this intimidation factor, the staff designed a series of Parent Workshops that would help adults have a meaningful experience at the Art Institute—or any art museum—with children. Now offered twice a year, the workshops attract a large and enthusiastic audience.

A guest speaker opens each workshop with a presentation on child development and age-appropriate learning. During the four-year Looking at Art Together initiative, three to four experts were brought in each year, including early childhood education expert Dr. Gillian McNamee, who talked about children's development in the arts from birth to age 10, and child psychologist Rebecca Mermelstein, who explained how a child's learning style comes into play when looking at art.

In small-group gallery walks, museum educators explain specific techniques for looking at art with their children. Carrying stools through the galleries, the participants—parents, grandparents, aunts and uncles, and other adults—gather in front of works of art, take notes, and never hesitate to ask questions. One educator uses a gallery of 17th-century Dutch paintings to suggest activities for a family visit, including an "I Spy" game that helps children look at a work of art slowly and in a focused way. Contemporary art—always a challenge for parents to explain—inspires many questions. Educators suggest focusing first on how a work was created, what shapes can be seen, or what memories are evoked. The workshops always include works of art that represent the collections' diversity. A stop in the African galleries to look at a mask might include a drawing activity to focus a child's attention on the patterns and textures.

Museum educators learned from Parent Workshops, too, by listening to thoughtful feedback from parents about how the museum could appeal to families. Communication materials—in print, on the Web, and in the museum—have a carefully conceived visual identity that is family friendly. Images of Artie the Lion, the family programs mascot, are everywhere, and children eagerly anticipate seeing Artie "live" when they visit. Virtual visitors can click on "kids + families" and go directly to the "Family Fun" section of the muse-

um Web site, where they can find out what's on the family programs calendar or read tips for a family visit. In 2002, the museum published *Looking at Art Together: A Parent Guide to the Art Institute of Chicago,* an idea-filled compilation of tips, games, sample visits, and at-home activities that helps parents explore and discover the Art Institute with their children. This new guide, which won the AAM Education Committee's 2003 Excellence in Practice Award, complements *Behind the Lions: A Family Guide to the Art Institute of Chicago,* which features information about works of art in the collection along with art activities for kids.

An unexpected outcome of the project was the extent to which it informed the planning of "Faces, Places, and Inner Spaces," the new interactive exhibition in the Kraft Education Center. Parents who attended Parent Workshops volunteered to participate in focus groups to critique the previous exhibition and contribute ideas for the new one. These sessions, Sousa says, "helped us create one of the most innovative family-friendly exhibitions we have ever had."

CHANGING PARTNERS

The four-year duration of Looking at Art Together gave the museum the flexibility to experiment with partnerships that had been untried and untested. In the process, the staff confirmed that increasing participation by population groups that do not typically visit the museum—in this case, African-American audiences—requires a complex, long-term effort. Early on, the museum decided to use churches and community organizations as links for increasing the number of African Americans who came to the museum and participated in programs. But the Art Institute does not have a history of such community-based relationships, so it was difficult to locate willing potential partners, establish solid alliances, and work with them to attract visitors. Eventually, the staff concluded that this aspect of its initiative was not as productive as they had hoped. "We found ourselves in the position of being the 800-pound gorilla, where staffing issues, trust issues, learning how to work together, were very challenging," says Eskridge.

Shifting gears, the museum has found compatible partners in similar-sized organizations with strong neighborhood and family bases, a dedicated audi-

ence, and delivery systems throughout the city that far exceed the museum's capacity. The museum now collaborates with the Chicago Public Library on Arts and Reading Together, a program that links visual and verbal literacy. Museum educators and librarians work closely together on activities that stimulate reading and looking at art, including a museum excursion for a Behind the Lions Family Day. Branch librarians can be community representatives for the museum to help raise the comfort level of people who may not otherwise think of visiting. With the library's help, the museum is reaching families of all cultural and economic backgrounds much more effectively than it could have done alone. The experience of Looking at Art Together also has positioned the Art Institute as an active collaborator in a citywide initiative, the ABCs of Art, sponsored by Chicago's Polk Bros. Foundation, which involves parents in implementing elementary school literacy programs beginning in pre-kindergarten. Building on the insights and techniques developed in Looking at Art Together, the museum education department is offering its first comprehensive, structured early childhood program geared toward teachers, children, and parents. This new program includes a range of services to enrich the curriculum offered in the Chicago Public Schools.

What's Ahead

Looking at Art Together marked a shift in thinking for the Art Institute's staff. "We have learned that to attract a diverse audience, we must have a diversity of programs, and we have altered our program offerings accordingly," Sousa says. "But what we have learned above all is that it requires more than quality content to create successful family programs. The essential component is an audience that feels comfortable and welcomed in the museum." This piece, she believes, requires a long-term effort that is heavily dependent on staff leadership and communication. Especially in such a large institution, developing and sustaining staff awareness of visitor-related goals is an ongoing process.

A new building designed by Renzo Piano, with one-third of its space devoted to educational facilities and programming, will dramatically expand the Art Institute's capacity to serve the public. James Wood explains that Looking at Art Together helped to focus priorities for the expansion. With its extensive use of natural light, the building "will literally open the institution up to the

surrounding city in contrast to the handsome, masonry temple that makes our original building a welcome refuge from the bustle of Michigan Avenue," he says. "The intention is to both enhance and expand the visitor experience by giving the institution a second face, no more or less important than that of the original Beaux-Arts structure, but which will allow the museum to both reach out in welcome and provide that essential sense of sanctuary." Family visitors are already one of the fastest-growing segments of the museum's audience— 200,874 visitors in 2003. With the space and visibility that the new building affords, the museum expects that family audiences could double in size.

Can a world-renowned museum also be a community museum? Wood does not believe there is a distinction. "Youth are our future, as well as the community's future, and the degree to which we can involve families in the museum experience can harness every parent's aspirations for their children to realizing the museum's mission. As for the balance between our responsibility as an international and a civic institution, I find little conflict, as one of our overriding civic responsibilities is to bring to and share with Chicago the finest achievements in the visual arts from throughout the world."

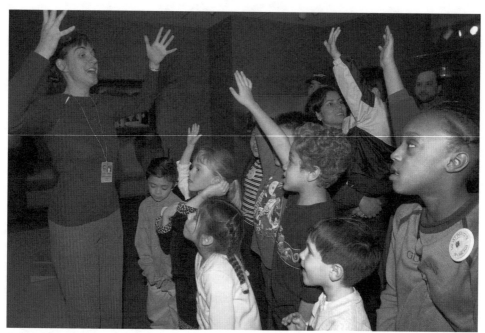

An educator gets kids excited during a gallery walk. ©Art Institute of Chicago.

A Renewed Vision

Isabella Stewart Gardner Museum

Isabella Stewart Gardner envisioned her museum as a place with vitality and spirit where the creative process could flourish and where every visitor could have an intensely personal experience with art. But after Mrs. Gardner's death in 1924, the museum was "not very lively," observes Anne Hawley, Norma Jean Calderwood director of the Isabella Stewart Gardner Museum. "The life of Fenway Court seemed to have exited with her." Over the years, the museum grew constrained by its founder's stipulation that the galleries remain permanently as she had arranged them instead of energized by her vision of "education and enjoyment of the public forever." In its continuity and predictability, the museum appeared static—a world-renowned collection preserved in a 19th-century time capsule.

During the past decade, the founder's spirit has been returning to the Gardner Museum. The museum's Pew initiative, called The Eye of the Beholder, set the stage for educational and artistic revitalization by providing a solid framework of school and community programs. Today, artists-in-residence inspire visitors, teachers, and students to see the collection from new perspectives, and in the process they build the relationships that are crucial to strengthening community connections. In-depth partnerships with neighborhood schools link young audiences to the museum and introduce them to artists. Professional development programs inspire educators to use the collection as a multidisciplinary teaching resource. Family programs and resources invite adults and children to explore the museum together.

When Hawley became director in 1989, she was determined to enliven the museum by embracing Mrs. Gardner's vision as a gift rather than a limitation. "It became clear to me and to our trustees that central to any new vision was a steadfast commitment to returning Mrs. Gardner's spirit and vitality to the

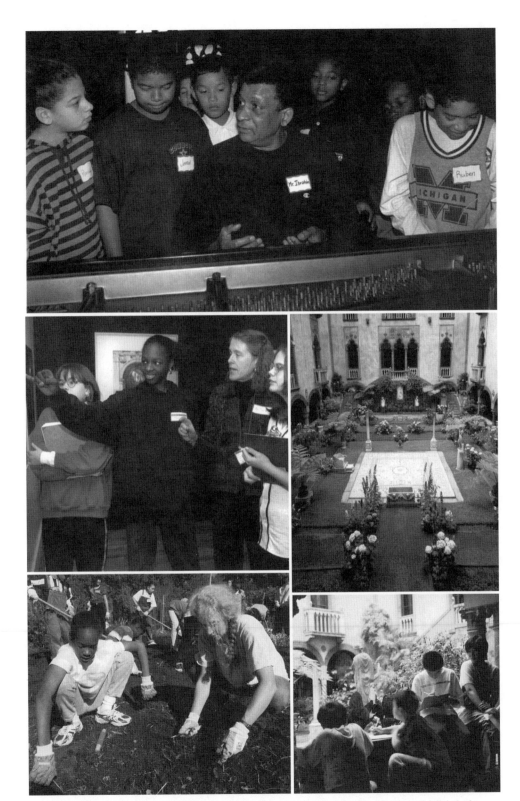

(Clockwise from top) 1. Fifth-graders from the Tobin School get a lesson in jazz improvisation from Abdullah Ibrahim. 2. The Gardner Museum courtyard inspires families to sketch together (3) during a Family Night program. 4. Artist-in-residence Joan Bankemper (right) works with students to create the Healing Garden. 5. Olivia Parker views an exhibition of her photographs with Boston Latin School eighth-graders (October 1997). ©Isabella Stewart Gardner Museum.

museum," she says. "We also knew that the preservation of the building and the conservation of the collections were as important as the need for new programming. Our board was willing to embrace these challenges, and they joined me in working to inspire people to want to spend time here, to want to make art here, to want to learn here."

The Eye of the Beholder took up these challenges, seeking ways for the museum to capitalize on its renowned collection and become a vibrant center for creative thinking as well as a neighborhood resource. As its focus, the initiative established an intersection of two programs: the education program and the artist-in-residence program. Partnerships with neighborhood schools seeded deeper relationships with teachers and students, and 22 artist residencies linked the community and the museum through the art of the present and the past.

Engaging Students and Teachers

The Gardner found school partners close to home, hoping to engage teachers, students, and families, begin building neighborhood interest, and ultimately create an audience for the future. "We were committed to establishing a stronger presence as a member of our neighborhood community," says Linda Graetz, director of school and teacher programs. Many requests for school tours were coming from suburban and private schools, and Hawley "wanted to reach those young visitors who can walk here and use the museum as a place to discover, imagine, and learn."

The education staff identified six neighborhood schools that had begun to develop relationships with the museum. They realized from the start that quality, in-depth experiences for students depended on developing each teacher's personal involvement. "Administrators do need to be invested," Graetz says, "but we cannot have meaningful partnerships with schools without close collaborations with teachers." This level of collaboration required museum educators and teachers—and artists-in-residence, when they were involved—to invest a significant amount of time to build relationships and develop new curriculum content. One way to build connections is to bring teachers into the museum without their students through the annual Teacher Institute, an

intensive one-day program for 30 educators that focuses on a theme and stimulates dialogue around issues of education in the museum setting. Smaller, Saturday-morning "retreats" for groups of 10 allow teachers to experience the museum on a more intimate and contemplative level.

The museum also experimented with teacher residencies, a program that is still evolving. The goal of the program was to provide another opportunity for teachers at partnerships schools to develop a better understanding of how to use museum resources—collection, staff, and teaching strategies—to create a new unit for their students. Now all Boston Public School art teachers are eligible to apply for the yearlong residencies. Over the past three years, several art teachers have developed and implemented imaginative teaching units in this way. But applications to the program are declining. "It's just a fact that teachers are under tremendous pressure to spend their professional development time on activities that relate to local and state standards," Graetz says.

Perhaps the most successful result of the Gardner's school partnerships has been the development of a multiple-visit model. Repeated visits—to the school by museum staff and to the museum by teachers and students—solidify the partnerships on many levels. Museum educators develop working relationships with individual teachers as together they map out curriculum content, school and museum visits, programs with artists-in-residence, family nights, and other activities for the school year. These repeated visits increase students' familiarity with the museum and expand their ability to think about and respond to art—good building blocks for the future. "We hear from teachers that one wonderful aspect of our format is that students fall in love with the museum and develop a real sense of ownership," Graetz says.

After attending a Teacher Institute focusing on conservation, fifth-grade teachers at Lawrence Elementary and Middle School decided to connect the Gardner's collection to their social studies curriculum, which deals with archaeology and ancient cultures. In the fall, museum conservators used a hands-on approach to involve students in a discussion about conservation issues. The students returned to the museum in the winter to discuss tapestries depicting stories from ancient Israel, a topic they were studying in the classroom. They also saw a special exhibition featuring contemporary textiles, learned about the conservation of tapestries, and experimented with weaving

techniques on small looms. Students extended their investigation of conservation in the spring by looking at works of art related to ancient Greece.

The Lawrence fifth-grade curriculum could just as easily have been studied in the classroom or with one field trip to the museum, but it was enriched by repeated connections with real objects. And even more important, both teachers and students began to see the Gardner as a significant place in their own community to which they had access.

MEANINGFUL CONNECTIONS TO LIVING ARTISTS

Initiated in 1992, the museum's artist-in-residence program invites up to six artists each year—visual and performing artists, poets, storytellers, and writers—for month-long residencies. Living and working at the museum, artists have time to find new inspiration for their own work in some aspect of the museum or its collection. While in residence, they also engage with the public through lectures or performances, classroom visits, and in-depth projects that support the curriculum in the Gardner's partner schools. The stories of two artists-in-residence—Lee Mingwei and Joan Bankemper—show how an artist's creative impulse can engage the community and enrich the school curriculum.

The residency of installation and performance artist Lee Mingwei illustrates the multiple roles and impacts of artists-in-residence. "While I was at the Gardner [in 1999], I became interested in the notion of hospitality and how Isabella Stewart Gardner demonstrated generosity in her Fenway Court home," Lee says. Returning to the museum in 2000, he created *The Living Room,* turning the special exhibition gallery into a contemporary living room that was inspired by Mrs. Gardner's way of opening her home to conversations about the arts. For nine weeks, "hosts"—first the artist, and then museum staff, trustees, volunteers, and guests—brought objects of personal significance into the space and invited visitors to join in conversations about them. Lee also went into the community to meet with two groups of students and discuss the personal significance of objects. Tenth-graders from Boston Arts Academy later created their own museum installation—a teenager's bedroom—and kindergarteners from the Mission Hill School made quilt squares based on objects that were important to them.

Visitors were fascinated by Lee's *Living Room* because it struck them as something completely different for the Gardner. "It adds a splash of vibrant modernity and . . . the serendipity of individual personalities to the otherwise static but perpetually beautiful" museum, one visitor wrote in the comment book. The impact within the museum was even more profound. Many hosts were having their first face-to-face contact with the public, and the whole experience led to an internal reimagining of Mrs. Gardner's vision for intimate conversations about art.

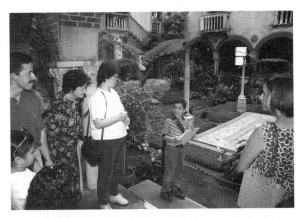

A Tobin School student invites family and friends to tour the Gardner's central courtyard during the end-of-the-year Family Night event. ©Isabella Stewart Gardner Museum.

This result was just what the artist hoped it would be. "I believe that the essence of this museum does not reside merely in its architecture and objects, but also in its staff and extended family, who make this place function as a living organism on a day-to-day basis," he explained. "By carrying on the organic process of sharing and entertaining, the museum regains its role as more than a mausoleum for inanimate, exotic objects."

Joan Bankemper, an artist who creates community gardens in urban areas, sees community as an integral part of the artistic process. When Bankemper was invited for a residency at the Isabella Stewart Gardner Museum, she proposed planting an herbal healing garden in the nearby Fenway Victory Gardens—the oldest community garden in the United States. The garden would be a work of art, a learning experience, and a collaborative community venture rolled into one. Today, this educational healing garden thrives near the museum, lovingly tended by fifth-graders from a neighborhood school and seniors who live nearby.

Bankemper knew that the physical, emotional, and financial commitment of building a community garden would be worthwhile only if it could be used and maintained. She and the museum staff found three natural partners. The Fenway Garden Society donated a plot for the planned healing herb garden. Pat Keyo, a

fifth-grade teacher at partnering Farragut Elementary School, realized that the garden project could offer a livelier way to teach the horticulture unit of her science curriculum. And neighborhood residents from the nearby Peterborough Senior Center were willing to help maintain the garden over the summer months.

On her first visit in the fall of 1999, Bankemper invited students into the world of plants—seen firsthand growing in the museum's greenhouses, observed in works of art in the collection, and explored as part of their own diverse cultural traditions. In the winter months, students researched the healing properties of herbs, created handmade books illuminated with botanical designs, and planted seeds in the classroom. When Bankemper returned in the spring, the students and seniors worked under her direction to complete the garden design and plant the seeds. In June, the students, their families, and the neighborhood elders celebrated the creation of the garden and attended the opening reception at the museum for Bankemper's exhibition, "A Gardener's Diary."

LESSONS LEARNED

By the end of the Pew initiative, Gardner Museum staff noted the challenges of linking the residency program with the school partnership program; balancing an artist's time for work and contemplation with time for public interaction is difficult. Over time, the museum modified the program to accommodate both goals as comfortably as possible. Artists are encouraged to spend one month in residence at the museum devoted to working on their art and then return several months later for the public components of the program.

Experimentation, say Gardner staff members, is a hallmark of their program. Flexibility is the key, as the staff looks for ways in which each artist can incorporate his or her own strengths. The museum continues to experiment in other areas as well: identifying artists who would fit well with the program goals, finding ways to get more of the museum staff involved with the artists-in-residence, creating programming opportunities for artist interaction with adults as well as students and teachers, assessing the short- and long-term impact on audiences, and maintaining relationships with past residents. Finding the right ways for each artist-in-residence to become part of the Gardner community inspires staff to be creative.

The artist-residency model also translates well to other arenas. The partnership model developed with artists and neighborhood schools, for example, has been adopted for the museum's work with community groups. In the summer of 2003, the Gardner hosted its first scholar-in-residence, with a process and product that parallel those of the artist residencies. "We are exploring the idea of creating a residency program that would increase from one individual at a time to three, adding scholars, conservators, or educators to the current mix of artists to inspire further interdisciplinary dialogue and creativity," says Peggy Burchenal, curator of education and public programs.

Moving traditional museum-school partnerships toward genuine long-term relationships is not an easy task. The Gardner has made great progress, and staff continue to address some important questions such as how to sustain interest and continuity and how to manage the limitations of the partnerships. New public programming—including summer Neighborhood Nights and Saturday programs—is proving to be effective.

TRANSFORMING LEADERSHIP

An important component to the Gardner's story of transformation is the steadfast commitment and visionary leadership at the board and staff levels. As the artist residencies and school partnerships progressed, an innovative futures planning effort revitalized the institution after years of insularity. In 1989, the small, seven-member board expanded for the first time since Mrs. Gardner's death, bringing business and civic leaders into the governance structure. When Hawley became director—and the planning process got under way—the board invited representatives of nearby communities to join the conversation. "The momentum and culture for change had begun," says Hawley. "I don't think a director is able to effect board change without this kind of commitment already in place. But once the commitment to change is in place, a director can help shape the vision, and guide the pace and direction of the change."

The momentum has continued. With the first major capital campaign in the mid-1990s, "we engaged a new group of leaders who were highly philanthropic and who believed in the museum's new direction. This new cadre of volunteer leaders became major donors and recruited others," Hawley says.

"The museum has been in a constant search for young leadership and for people who have a strong interest in one of the museum's programmatic cornerstones—historic art, contemporary art, music, horticulture, and education."

The planning process also involved what the museum called "animator panels": groups of four to six people with expertise in each of the five cornerstone areas. Participants were asked to engage in a dialogue about programming that would help to "animate" a plan for the future and tease out best practices and program models. Panelists included landscape architect Laurie Olin; Harvey Lichtenstein, former president and executive producer of the Brooklyn Academy of Music; art historian Stephen Campbell; composer and Julliard faculty member Robert Beaser; and Rev. Ray Hammond, community activist and pastor of Bethel African Methodist Episcopal Church. Panel meetings began with statements by each member, which sparked group discussion. The audience of museum trustees, overseers, and staff was then invited to join the discussion. A white paper synthesized the ideas that emerged.

"The animator panels served as public forums, in a sense, and prevented the museum from becoming too inward-looking in its quest to define its future," Hawley says. "We turned ourselves outward, . . . and this openness to new ideas dramatically influenced the quality of thought in the process of designing a plan for the future."

A CENTENNIAL ANNIVERSARY

The renewal of the Gardner Museum is still in progress. "Our work to bring education and artistic programs to an optimum level of excellence and capacity continued after the Pew funding ended," Hawley says. "I now estimate that it will take at least until the end of the decade to build our endowment in order to provide secure and permanent funding for the programs that have become critical to sustaining the life of the museum." As this endowment-building and fund-raising effort begins, "it is a tangible opportunity to use expanded program offerings to draw in new constituents and develop a broader base of prospects and donors who will be important to the museum in future years," explains Burchenal. "Simply stated, expanding programmatic

capacities will extend our reach to the communities we serve as well as ignite the imagination and support of many new friends."

As the Gardner celebrates its centennial in 2003–2004, those programs are helping to revitalize the museum that Isabella Stewart Gardner hoped would be a vibrant source of beauty, education, and enlightenment for the public— from nearby neighborhoods and the world beyond. "We are committed to a long-term strategy of providing more introductory experiences for visitors," says Peggy Burchenal. So on summer evenings, the Gardner keeps its doors open late for several free Neighborhood Nights. Gallery activities and live performances draw new audiences to the museum and, ideally, entice them to return in the future. The museum's inviting new public face is also evident on Saturday afternoons, with programs designed to welcome any visitor, but especially first-timers. As Mrs. Gardner intended, the historic collection blends with the work of contemporary artists—and with the horticulture and music that have long been part of the museum—to offer an experience that takes shape through the eye of the beholder.

More than a Museum

WALKER ART CENTER

The neighborhoods around the Walker Art Center in Minneapolis are a study in diversity. Residing here are descendants of the area's oldest European immigrants, one of the largest urban Native American populations in the country, and recent arrivals from Asia and Africa. Separating the Walker from some of these neighborhoods is a busy highway that can seem like a socioeconomic divide as well as a physical inconvenience.

With the arrival of director Kathy Halbreich a little more than a decade ago, the Walker began an ambitious effort to become a different kind of neighbor—inviting, engaging, and respectful of the cultural richness that thrives right in its backyard. The museum tried a combination of programming and benefits, such as free evenings and special memberships, and involved artists-in-residence. But the programs originated largely at the Walker; they were programs *for* the community, not *with* the community.

The museum asked community organizations what resources it could offer their constituents. The answer: more direct interaction with artists. So in 1999, the museum decided to refocus its multidisciplinary artist-residency program to center as much on audience engagement as on presenting. A three-year initiative called Artists and Communities at the Crossroads moved the Walker across the highway and into lively partnerships with people and organizations in 10 nearby zip codes. The initiative's intent was to integrate the artistic process more fully into people's lives and illuminate the ways contemporary art encourages us to explore significant issues that shape our everyday existence.

As the initiative began, the Walker had just completed a long-range plan that expressed the museum's vision in this way: "A pioneering 21st-century multi-

1. View of the Walker Art Center expansion from Hennepin Avenue at dusk, 2003. ©Herzog & de Meuron. 2. During his artist-residency, choreographer Bill T. Jones, pictured here with local dancers, involved the community in a performance of his work. 3. Walker on Wheels, a mobile art center designed by artist-in-residence Joep van Lieshout, has been used to host everything from artists' talks to ice cream socials. Photos (middle and bottom) by Dan Dennehy; ©Walker Art Center.

disciplinary art center with audience engagement and experiential learning at its core, Walker will become a pleasurable destination—real and virtual—that is not event dependent." Moving away from the episodic special exhibition model, the museum aims for "an ongoing 'blockbuster' experience which is indispensable to the life of the community and a model for the field." Audience engagement is at the center of the mandate, supported by interconnected strategies related to creative expression, multidisciplinary programming, the physical and virtual environment, and constituent service. "We want to make art more legible to more people, so we have come from being artist-centered to being bifocal," Halbreich says. "More than a museum," the Walker's slogan, is an apt description of the change in progress.

Much of the transformation has revolved around planning for a major expansion, designed by the Swiss architectural firm Herzog & de Meuron in partnership with Minneapolis-based Hammel, Green, and Abrahamson. The new building, scheduled to open in 2005, is a multidisciplinary public space geared toward open-ended exploration and individualized experiences—equal parts public forum and public museum. It will change the Walker's face—and the visitor's experience—dramatically. "We had a responsibility to think about creating a town square," Halbreich explains, "a place where people could safely and comfortably be exposed to and debate values from down the street and around the globe—because sometimes the values down the street *are* from around the globe." She envisions it as a "lively environment, operating day and night in which all the art forms are accessible and . . . the art experience is centered on the interests of the visitor."

Added to the mix was Artists and Communities at the Crossroads, which had three goals: audience awareness and appreciation of the Walker; audience engagement in the creative process and experiences with contemporary art; and collaborative planning across museum departments and with community partners. The museum had experience with commissioning works of art and then connecting artists-in-residence with community-wide audiences through master classes and lectures. It also had been targeting particular audiences—teens, low-income families, and people of color. "We hit upon . . . the need to extend the audiences we were working with and yet also narrow [the field] so that the project could be workable," says Sarah Schultz, director of education and community programs. "We defined a community

within a two-mile radius of the Walker, the idea being that it was a microcosm of the city: the richest people, the poorest people, the oldest residents, and the newest immigrants."

Artists and Communities at the Crossroads was a series of community-oriented artist residencies in film/video, performing arts, and visual arts combined with educational and community programs. In the community, the museum worked with organizations as diverse as the Association for the Advancement of Hmong Women, Native Arts Circle, Shakopee Correctional Facility for Women, and Powderhorn Park Neighborhood Association. Within the museum, collaborative relationships between curatorial departments and the education and community programs department supported program planning and development. Howard Oransky, director of planning, explains that by the end of the initiative, "we had gained confidence and essential skills in our ability to make and sustain connections with various community members through the arts. Artists and Communities at the Crossroads also transformed the working relationships within the museum."

QUESTIONING TRADITION

It soon became clear that Artists and Communities at the Crossroads reflected the Walker's reputation for risk taking. The initiative's artist residencies shifted the balance of decision making and even art making, and the ways in which artists-in-residence engaged people from the community were as diverse as the community itself.

◆ Filmmaker Cheryl Dunye collaborated on the development of the script for her feature film *Stranger Inside*—about a mother and daughter reunited as prison inmates after a long separation—with 12 inmates in the Shakopee Correctional Facility for Women. The film premiered at the Sundance Film Festival and was a critical success when it aired on HBO in 2001. Readings in the prison and at the Walker along with a public screening of the film were part of the residency, which took shape with the help of the Walker's Community Neighborhood Advisory Committee; AMICUS, a nonprofit organization that helps offenders build successful lives; and the Minneapolis College of Art and Design. "Working with people who are real,

you get an authenticity, truth, and passion," Dunye explained. "The Walker is one of the few mainstream art organizations that is willing to support artists in taking these kinds of risks. It's like the Walker gives artists legs."

◆ An extended residency with the Bill T. Jones/Arnie Zane Dance Company began with a planning session with nearly 30 community organizations. In 2000, Jones held four workshops—at Macalester College, the YWCA, and the Walker—to involve community members as he developed *Loud Boy*, his dance-theater interpretation of Euripides' *Bacchae*. Members of his company offered master classes, open rehearsals, lecture-demonstrations, and a performance for other segments of the community. Later that year, the work was the focus of an exhibition in the museum's Anderson Window Gallery that was seen by 245,000 visitors. Jones and his company returned the following spring for a two-week residency, which included community involvement in a performance of his work, *The Table Project*, commissioned by the Walker. "Working in the community makes me feel part of something," Jones said. "I am gratified when I can see the light go on and young people understand something they didn't before they arrived."

◆ During his residency in 2000, Nari Ward created *Rites of Way*, a work that focused on Rondo, a historic African-American neighborhood in St. Paul that was bisected in the 1950s to make way for an interstate highway. Ward wanted to "create something that honored all participants," and the Walker's staff and community groups found people in the community to work with him. The result was an abundance of ideas and creativity. Ward conducted workshops with African-American women, people in the Hmong community, homeless teens, and others. People donated objects that related to their stories and mailed them to addresses in Rondo that no longer existed. After they were returned through the postal system, the objects and their stories became part of *Rites of Way*. More than 442,000 visitors saw the work while it was on view in the Minneapolis Sculpture Garden from September 2000 through June 2002.

The 17 artist residencies challenged the museum's traditional beliefs, Halbreich explains, and raised new possibilities for a more public, extroverted role for curators in a contemporary art museum. Artists are no longer "practitioners working alone in a lonely studio," she says. "Instead they are

activists without a particular political agenda working alongside those whom they hope will find their work transforming." Similarly, "the best curators are partners with artists. They no longer are lonely practitioners working away in the library or their office. They are out in the community." The resulting work tends to provide a "converting moment" for curators, Halbreich says. "There is incredible pleasure on the collective curatorial face when they see people speaking different languages in the Walker, people coming from different neighborhoods, people who didn't feel invited but who are now participating."

TRANSFORMED COMMUNITY RELATIONSHIPS

The Walker's community network includes youth programs, ethnic-based groups, social service groups, parks, artistic groups, schools, and others. Akhmiri Sekhr-Ra, community arts organizer at the Powderhorn Park Neighborhood Association in Minneapolis, describes the evolving balance of the partnerships: "At first, the Walker was putting a lot of the work into trying to build the relationship. Now we are kind of equal to them and are able to stand on our own. We have a lot more to bring and to give. It's not always about funding. It's about how can we include them in our project."

The Cathedral Basilica of St. Mary is a vital part of community life and an active Walker partner. Johan van Parys, director of worship, sees the basilica as a modern medieval cathedral. "The arts are terribly important for us, but without the Walker, we wouldn't be able to focus on the arts as much," he says. The Walker also invigorates the church's social impact. "A religious group can't push the envelope, so we have to rely on other institutions to move beyond the status quo." So far, he explains, the relationship has operated on two levels: co-promotion and collaboration. In the future, he hopes the two institutions will move to the co-creation of arts programs in the community, with each bringing ideas to the table.

Peter Rachleff, professor of history at Macalester College in St. Paul, describes the broader benefits: "I do most of my work in the labor movement and communities of color, and I don't come out of the arts," he says. "I would say that there are two preconceptions that have really been exploded for me and the people that I work with. One is that artists are prima donnas, and the other is that the Walker is an elitist institution."

Some of the most effective partnerships have involved the museum's mobile art center. Created by visual artist-in-residence Joep van Lieshout, Walker on Wheels (WoW) has found multiple uses as meeting room, art studio, and media lab. In 1999 WoW began its travels to schools, parks, and community centers, providing a flexible space for multidisciplinary activities designed and implemented in collaboration with neighborhood organizations. It has been used to host everything from artists' talks and exhibitions to an ice cream social and hands-on art making.

In the Powderhorn, a diverse neighborhood in south Minneapolis, the Walker has an ongoing partnership with the Powderhorn Park Neighborhood Association. Filmmaker Spencer Nakasako transformed WoW into a media lab stationed in the park, where he taught young Native American residents to portray their lives in digital video documentaries. In connection with her residency, Joanna Haigood worked with 16 teens in an after-school residency program. The teens interviewed Powderhorn residents, recorded sights and sounds of their neighborhood, and created narrative panels that were displayed in WoW while it was in the park.

In the beginning, the Walker did what many museums do when trying to strengthen community relationships: established a community advisory committee. Eventually, the committee was dissolved because it proved to be an unnecessary layer in the process. The museum had a growing network that was producing new community partnerships without a formal committee structure. The logistics of maintaining the network as large as the Walker's are complicated and labor intensive. Individual connections are important to building sustainable long-term relationships, but staff turnover requires an ongoing investment of time to keep relationships vital.

MEASURES OF TRANSFORMATION

The Walker Art Center's experience points to a familiar quandary: quantitative measures may not always tell the whole story. The Walker fell short of its overall goal of a 10-percent rise in attendance, membership, and volunteerism among the target audience. (However, gallery attendance increased by 58 percent, and attendance was not counted at the many well-attended but untick-

eted artistic events presented in communities.) Still, community organizations were positive about the experience. "The process used by the Walker was exemplary," one community partner said. "It has become a gold standard for my organization in terms of how a large arts organization nurtures a relationship with a community group."

Artists-in-residence, such as choreographer Liz Lerman (with back to camera), helped the Walker transform its relationships inside and outside the museum. Photo by Dan Dennehy. ©2004 Walker Art Center.

Says Oransky: "Ironically, we can at least partly attribute the quantitative shortcomings to the rapidly changing demographics of our surrounding neighborhoods, which is the same phenomenon that inspired our proposal in the first place. One of our greatest challenges as we move forward will be how we choose to balance the staff resources we put into labor-intensive artist residencies that have an impact on a small segment of our audience with our efforts to reach a much broader audience."

There is a clear sense, however, that Artists and Communities at the Crossroads profoundly affected the Walker's staff and the artists, community partners, and audiences who participated. Oransky says that "the most common response participants have voiced regarding their experience in the residencies is that they come away from it looking at their world, not just art, in a very different way." One activist and community organizer who helped with musician Fred Ho's residency said his constituents thought that theater was entertainment. "That was leisure and that was something over there. And now [they] see art, theater in particular, but also dance and music, as ways of expressing ideas, and ways of inspiring and motivating people and building community." "We have learned," says Sarah Schulz, "that people who have intensive experiences in the artist-residency programs have a much better understanding of the creative process, are much more willing to engage with contemporary art, have a much better feeling about the Walker, and have a much better feeling about a continuing relationship with the Walker."

Within the museum, Artists and Communities at the Crossroads led to lasting changes in the quality and frequency of staff communication. At first, the curatorial and education departments didn't work closely on the artist residencies they were planning. But it soon became clear that curators and artists would benefit from the educators' knowledge of the community. Over time, the staff honed their system of close cooperation. "We have had a number of challenging situations arise over the years," Oransky says, "and each one has been handled as a team working together to represent the Walker." Most important, the procedures are entrenched in the museum so that they will not be affected by staff changes.

The real power of Artists and Communities at the Crossroads was the awakening of a community-centered focus. The initiative has had a profound effect on the planning process for the new building, where the possibilities for direct participation in the creative process will be multiplied. The goal is to make the museum an inviting place for all members of the community.

"We are now asking ourselves what it means for a contemporary art museum to be a community gathering place and forum for the discussion of civic issues," Schultz observes. "How can art and artists play a critical role in the discourse of evolving democratic communities? How can we better connect art and public life? How can creative and intellectual expression promote awareness, understanding, and tolerance between diverse communities? Our ability to even pose such questions, to imagine solutions, and to be open to unknown outcomes is in large part a result of the individual and collective growth we experienced through Artists and Communities at the Crossroads."

Meanwhile, engagement with art at the Walker continues in the refreshing way that people in the community anticipate. From Memorial Day through Labor Day, an artist-designed, 10-hole miniature golf course will be constructed across the street in the Minneapolis Sculpture Garden as part of Walker without Walls, a series of city-wide programs taking place during the final construction phase for the new building. Guidelines for the juried golf course design competition explain that each hole must be durable enough to withstand "direct exposure to . . . an enthusiastic, club-wielding public of all ages."

A Museum in the Mood for Change

CARNEGIE MUSEUM OF ART

On a crisp, sunny January afternoon, powerful images of mid-century Pittsburgh by the master photojournalist W. Eugene Smith draw a steady stream of visitors to Carnegie Museum of Art. Gestures, expressions, and snippets of conversations suggest that more than a few of them remember this industrial landscape and the decline of the steel industry that eradicated it. Seeing Smith's iconic photographs—the entire photographic essay has been assembled together here for the first time—has stimulated people's memories and the urge to share them.

Knowing that Smith's images would evoke recollections, emotions, and curiosity about the city's history, the team of curators, educators, and designers created an exhibition with the audience in mind. "Dream Streets: W. Eugene Smith's Pittsburgh Photographs" was a departure for this once-aloof museum, and just one indication that Carnegie Museum of Art has come down off its pedestal. Now, board and staff are turning the museum into an extroverted, audience-centered "cultural shaper" that challenges people to think about the world through art.

This transformation in attitudes, practices, and public image began with a three-year planning grant for audience research and educational initiatives from the Program for Art Museums and Communities. For the first time, the board and staff had solid data about audience perceptions and expectations that confirmed what they had suspected: Many people in Pittsburgh viewed the art museum from a distance but really wanted to be invited in.

The Pew grant "opened a door through which we could channel a lot of disorganized energy," says Richard Armstrong, the Henry J. Heinz II director. "This was a very under-examined, un-self-conscious institution" until the research

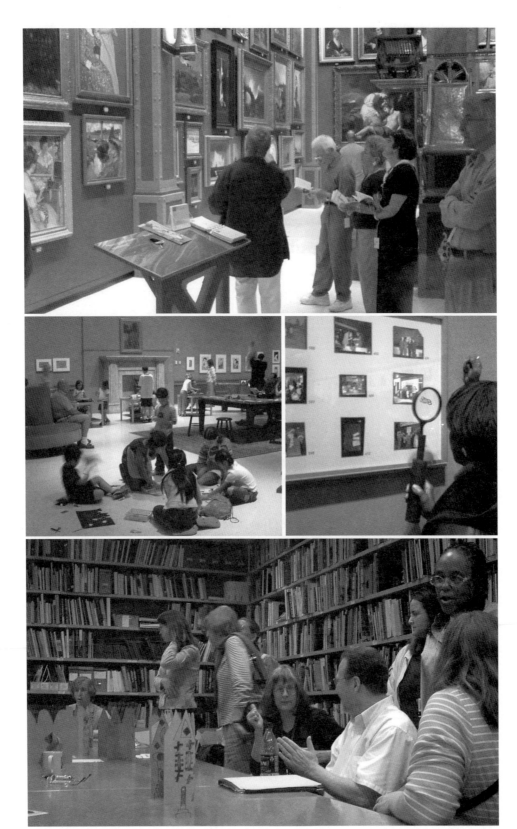

(Clockwise from top) 1. Visitor comments led to a dense installation, dark-colored walls, and visitor-response stations for the Carnegie's popular "Panopticon" exhibition. 2. Viewers of Teenie Harris's photographs were invited to share their own memories of the subjects on display. 3. Stories in Art—librarian resource day at the museum. 4. During an ARTventures activity, young visitors sprawl on the floor to create their own responses to "Panopticon." ©Carnegie Museum of Art.

effort "turned the whole place upside down and inside out." The catalyst was the board's vigorous, enthusiastic backing—both conceptual and financial. "We began to engage with the public in ways we had not done before."

The turnaround at Carnegie Museum may not seem dramatic on the surface, but for a museum that had maintained the traditional distinction between education and collections, the transformation has been remarkable. "The trustees have really come along with the notion that this can be a dynamic, inviting, contemporary museum with a strong civic role," Armstrong says. Increased board-staff interaction includes joint strategic planning and board committee work. For the first time, cross-departmental staff teams collaborate on exhibition and program development. The visitor experience is a factor in decisions about exhibitions and collections. Education and marketing are built into exhibition budgets. Research continues as an integrated activity, not an occasional initiative, so the staff can monitor and respond to visitor satisfaction levels. A full-time community liaison specialist based in the education department builds relationships with people and organizations in the region.

Beginning in 1998, an intense exhibition and programming schedule supported by expanded marketing yielded unprecedented growth in visibility and visitors. By 2003, however, the overall economic situation forced severe budget cuts throughout Carnegie Institute, including the temporary elimination of the art museum's well-regarded film department. The scale and scope of exhibitions, programs, and marketing have been affected, and the museum has revised its plans for a capital campaign and new entrance pavilion.

But the fortunate news is that the community-oriented values shaped during the years of the initiative are ingrained into the museum's operations. "Our budget and staff cuts have catalyzed our thinking even more purposefully," says Marilyn Russell, curator of education. "Our responsibility to the community is now central to the way we do business."

THE READINESS FACTOR

Just a few days after Armstrong became director in 1996, he flew to San Diego for the annual forum of the Program for Art Museums and Communities. The

thoughtful, animated discussion of issues surrounding museum-community relationships was an unfamiliar and not terribly comfortable context for the former curator of contemporary art. But soon after the meeting, the museum's consulting team presented findings from its initial research. Filtering this information through what he had heard at the meeting, Armstrong was sold on the notion that the Carnegie Museum of Art could be a much more dynamic community and regional presence. "There was a readiness factor here, just as there had been in the other. What I heard at that San Diego meeting was the importance of timing—a new director there, a catalytic bond issue, a change in board leadership. I realized what a great opportunity we had in Pittsburgh, and then the audience research confirmed for me that we couldn't go on indefinitely staying at arm's length from a community that wanted very much to be part of our museum."

The research results came at precisely the right time, Armstrong says. "The museum was in the mood to change. We had new leadership, both professional and volunteer, and an accompanying shift in attitude that was promoted by a new willingness to talk to one another. At that moment came the infusion of capital from Pew that encouraged the board to feel that it had a certain largesse. That leveraged a considerable amount of money and a considerable amount of interest."

PERCEPTIONS AND POSSIBILITIES

The questions that launched Carnegie Museum of Art's research effort may be familiar to some institutions, but this museum was asking them in a formal way for the first time:

◆ How do people perceive the museum?
◆ When they visit, what kind of experience do they have?
◆ When they don't visit, why not?
◆ What can we do to make this museum, which is the largest art institution in the region, the accessible community resource we know it could be?

Consultants Alan Newman of Alan Newman Research, Gail Lord of Lord Cultural Resources, and Ron Porter of RDP Consulting designed a strategy of seminars, interviews, and formal research to identify perceptions of the muse-

um and barriers to participation among the regional population and two targeted audiences: African Americans and families with children. The audience research was reinforced with two community-based program initiatives—a library partnership and a school partnership—designed to test the effectiveness of increasing familiarity with the museum as the first step to increasing participation.

Some of the research findings were no surprise. The two targeted audiences were not well represented among museum visitors, the overwhelming majority of whom were Caucasian. Although these audiences and the general population both had a favorable image of the museum, it was not high on their list of places to visit. They felt that the museum's perceived elitism made it a "hard sell" to the community. Other findings offered new and useful insights. African Americans, much more so than other groups, said their primary motivation for visiting the museum is to teach their children about art. Non-African Americans visit for personal enjoyment or edification or to see a particular exhibition. In an interesting series of complementary interviews, museum donors, trustees, and foundation executives expressed similar sentiments.

LEADING CHANGE

The museum responded immediately by launching a board-staff strategic planning process that charted an extroverted relationship with the community from 1998 to 2001. An ambitious exhibition, programming, and marketing agenda was set in motion. Carnegie Institute trustees earmarked $5.5 million over three years for a comprehensive marketing program for the art museum, Carnegie Museum of Natural History, Carnegie Science Center, and the Andy Warhol Museum (known collectively as Carnegie Museums of Pittsburgh). According to Jim Wilkinson, former chairman of the Trustee Marketing Committee, "this attempt to become more 'customer-driven' was not designed to be a short-term advertising blitz to increase attendance or earned income. Rather, it involved a fundamental rethinking about the interrelationship of our public programming, our audience, and our role in the community to position [the museums] for the future." A board-staff committee was formed to develop a three-year marketing plan.

As part of the marketing agenda, the museum engaged in an extensive and unprecedented amount of research. For the first time, focus groups helped decide the title of an exhibition ("Aluminum By Design: Jewelry to Jets") and strategize marketing and communication pieces. Focus groups and audience surveys following major exhibitions confirmed the strength and appeal of exhibition content and programming and identified opportunities to improve the visitor experience with amenities such as better wayfinding, café offerings, and parking. Other initiatives included major marketing and advertising campaigns and collaborations with regional organizations, such as the Greater Pittsburgh Convention and Visitors Bureau, to use the museum and its exhibitions as a cultural tourism attraction. An enhanced museum Web site extended communication to new audiences.

The museum understood that transformation would require significant changes to the culture and composition of its board. Armstrong describes the shifts in style and substance: "Once, discussion on the board was basically stifled. Now discussion is encouraged. It's a participatory process now, as it never has been. Part of the relief that people feel is that they know one another on a first-name basis, board and staff. Neither side feels isolated. The trustees were ready to get out of their dinner clothes; they just didn't know how comfortable and easy it could be."

Trustees are more comfortable with sharing power, receptive to new ideas, and willing to invest not just financial resources, but time and energy. "They are well-meaning, dutiful people who believe it's their obligation to be available," Armstrong says. "The perceived social snobbery, to a large degree, has been uprooted." Their demographic profile is beginning to change as well—a critical step for a board that has been self-perpetuating. Three African-American trustees now sit on the 36-member board; in 1996, there were none. Twenty-two percent of the board is over age 80, but in an attempt to bring new perspectives to the board and to engage succeeding generations in governance, every new member since mid-2000 has been under age 45. Other demographic characteristics are changing as well.

"There were never any skeptics on the board about the museum becoming a more extroverted and open institution," Armstrong says. "That's now presumed to be the museum's principal attribute." In part, the research findings

Response stations in the "Panopticon" exhibition encouraged visitors to write about and reflect on works of art. ©Carnegie Museum of Art.

appealed to some traditional beliefs. "We found that we had an intersection of desires when our marketing studies showed that people who don't visit the museum were interested in being uplifted. They saw the museum as a place to broaden their children's horizons and expose them to a better life. When you talk to trustees about the museum as a site for dialogue and discussion, that doesn't go anywhere. But when you say it provides access to higher values, they understand that." Says board chair Marcia Gumbert: "One of the most important changes that has occurred has been the confidence Richard Armstrong and his staff now have in the board. They know that this board is dedicated and behind them in anything they wish to pursue and is limited only by finances."

AN INCUBATOR FOR IDEAS

In the years since the Pew initiative, the museum has been a laboratory for experimentation. "The effects have been cumulative," Russell says, "and we continue to do more and more." At first, the efforts were somewhat diffuse—occasional staff collaboration, an exhibition with a strong educational component, a new community partnership. But as ideas about visitor engagement took hold and showed results, "we have been able to transform the experience for visitors. As a staff, we talk about the impact the audience has on the museum, not only the impact we should have on the audience. This analysis is happening collaboratively across all departments."

Cross-departmental teams—a new concept for this museum—have become more common in the years since the Pew planning grant. Collaborative planning for the W. Eugene Smith exhibition in 2001 was the first truly "seamless"

team effort, says Linda Batis, associate curator of fine arts. "We wanted to make the material as accessible as possible, and we wanted the education department's help in doing that. The process made a huge difference in the way we do things." The museum also has begun to engage high school students—not just as visitors, but as collaborators in developing and presenting public programs. Students from several area high schools were enthusiastic participants in the 1999 "Carnegie International," producing a video and a publication, leading gallery discussions for their peers, and organizing a day-long event for teens. For most major exhibitions—including the next "Carnegie International" in 2004—"teen ambassadors" design and implement activities for their peers.

A major reinstallation of the permanent collection, which opened in October 2003, clearly reflects the lessons learned. During the 14 months of renovation, nearly 500 works of art were on view in "Panopticon: An Art Spectacular," a floor-to-ceiling installation modeled on 19th-century salons and world expositions. "Panopticon" was both a way to keep the museum open while the main galleries were closed and an incubator for visitor-centered ideas. Visitors commented enthusiastically that the dark wall colors and dense installation were less intimidating than widely spaced works of art on vast white walls, so these design elements were used in the new galleries. Other new features—many of them the product of cross-departmental teams—include improved maps, way-finding systems, and gallery signage. There is significantly more narrative wall text, ample comfortable seating furniture, an audio tour with family-oriented segments, and "writing stations" where visitors can read, write, draw, and reflect on the works of art. ARTventures, the museum's popular gallery art-making activity, finds kids and adults engaged in collection treasure hunts or sprawled on the floor creating their own response to the collection.

"All this is new for us," Russell says. "Our galleries are vibrant with activity. And much of it is a result of the ongoing Pew meetings with my colleagues where we developed innovative ideas and supported each other's struggles. I returned to Pittsburgh each time fueled with new strategies to try in our galleries with our audiences. Several curators now insist that we design hands-on activities for exhibitions." "Sometimes former curators are slow to recognize the many ways an exhibition can be animated. I certainly was," adds Armstrong.

INVITING PARTICIPATION

The museum's audience research confirmed that it was somewhat isolated from the public, but it was an especially distant presence for African Americans. Community Liaison Deborah Starling Pollard's job is to explore ways to change that. Pollard had never worked in a museum before she joined the Carnegie's education department in 2001. With a professional background in business and an eclectic variety of volunteer interests (including teaching mime to seniors and working with children in Reading Is Fundamental), Pollard took on the challenge of building community relationships in an institution that people perceived as isolated and elitist. To make the museum more visible, she began by becoming a visible presence herself, visiting neighborhood festivals, getting to know staff in the museum's branch library partners, and devising ways to adapt existing programs so they would appeal to people who might not think of visiting the museum. At first Pollard's position was funded by the Pittsburgh Foundation; in 2002, despite budget and staff cutbacks, it was incorporated fully into the museum's operating budget.

Pollard also is working on a major long-term goal: helping low-income families feel comfortable about visiting and participating in the museum. A new program called Stepping Stones gives free annual museum memberships to 40 families, some identified by the Bedford Hope Center and the Hilltop Community Children's Center. By building relationships in small increments through Stepping Stones, Pollard hopes that the museum will begin to feel more welcoming. "'Free days' aren't enough," she says. "We need to be out there in the community, and we need to provide the incentives that let people know we sincerely welcome their participation."

Penetrating the art museum culture isn't always easy. Marilyn Russell points out that "it's important to us to have people on our staff who come from other fields because they can remind us when we're speaking our own language—a language that many people outside the museum don't understand." Pollard acknowledges the challenge of introducing a new way of doing business. "This museum had never approached community organizations," she says, "The constituencies of those organizations—the people we want to become visitors—don't come to museums and have a perception of them as elitist."

Two important educational initiatives continue to extend services to the community, especially the museum's target audiences. Stories in Art, a collaboration with the Carnegie Library of Pittsburgh, was designed as a catalyst for lifelong museum-going. Monthly presentations for children in branch libraries throughout Pittsburgh link children's books to works of art in the collection. A trip to the museum is a highlight of the year for participants and their families, and for many of the children, it is their first museum visit. The Stories In Art team now presents 20 programs each month in area libraries and remains a much-loved program despite the need for constant fund raising. A successful partnership with Boyce Middle School that involved multiple museum visits for sixth-grade social studies classes was the model for a current partnership with the Extra Mile Foundation, which supports four neighborhood schools serving African-American students. Insights from both programs have inspired more—and better—community collaborations.

THE TRANSFORMATION CONTINUES

Today the Carnegie Museum of Art is an active laboratory where the possibilities for reaching and serving audiences are being tested constantly. Even with severe budget and staff constraints, the exploration continues. "Our grant enabled more research, more investment in people, and more investment in advice," Richard Armstrong says. What the museum learned as a result has been integrated into the museum's values and practices. Still, Armstrong says, "we've had to make some very painful choices that affect our public service," including postponing renovation and expansion of the museum entrance, cutting the marketing budget, and eliminating Thursday evening hours. The reopening of the permanent collection promises to be a bright spot, because the new installation makes this community resource more inviting and accessible.

On an October Saturday afternoon, museum visitors again are captivated by Pittsburgh photographs. This time they are the work of Teenie Harris, who documented African-American life for the *Pittsburgh Courier,* one of the most influential black newspapers in the country. Harris's substantial archive—more than 80,000 negatives dating from the mid-1930s through the mid-1970s—is now in the museum's collection. Many of the 300 work prints in the

exhibition "Documenting Our Past: The Teenie Harris Archive Project" are unidentified, so visitors are sharing their memories of the people, places, and events Harris photographed. Teen guides are in the galleries, too, answering visitors' questions and pointing out interesting images. As part of the Harris project—and as a direct result of the work Deborah Starling Pollard has been doing in Pittsburgh neighborhoods—an oral historian is visiting branch libraries with some 3,600 images, photocopied and placed in notebooks. Library visitors peruse the photographs, share reflections and make comments, and suggest which ones to include in a future, major exhibition.

By capturing a moment when board, staff, and community were primed for change, the extroverted Carnegie Museum of Art used some basic audience research as the springboard for transformation. Quantitative information made a qualitative difference. Although it is too soon to know the impact on audiences, the impact on the museum's own principles and practices has been profound—even in the midst of a serious economic downturn. As Russell observes, "in what is obvious to the visitor and in the way we do our work behind the scenes, it is and continues to become a very different museum."

A Valued Resource for Educators

SEATTLE ART MUSEUM

For several decades, arts education has been steadily disappearing from American classrooms. Despite research showing that arts education supports children's intellectual and emotional development, it is frequently among the first casualties of financially strapped schools, overextended teachers, and standards-based teaching. In this climate, museums are logical places for teachers to turn for help in restoring the arts to their instruction.

When the Seattle Art Museum (SAM) began its Pew initiative in 1996, the time was right to reinvent its relationship with the educational community. "Teachers and students should feel welcome and take advantage of this great art museum," notes Illsley Ball Nordstrom Director Mimi Gates. "We are determined to work proactively to ensure that SAM and the visual arts are an important part of students' lives." The museum did not have a strong association with schools in Seattle or the King County area, but it had resources in its multicultural collection to share. The arts program in the Seattle Public Schools was sparse and uneven, and it was not implemented under district guidelines but instead was the result of initiatives by individual teachers, or principals, or parents at a few schools. The late John Stanford, former district superintendent, and the school board were committed to revitalizing the program by the year 2000. The Seattle Public Schools emerged as ideal and eager partners for the museum.

By creating a systematic, sustainable program that serves teachers and students, SAM staff aimed to make the museum and its collections more accessible as classroom resources. They wanted a fresh, active, mutually rewarding relationship with local educators in which students gained new knowledge and skills. Over the long term, they hoped that this museum experience would nurture a comfortable lifelong involvement with the arts. Teachers would seek out museum resources with confidence, and students

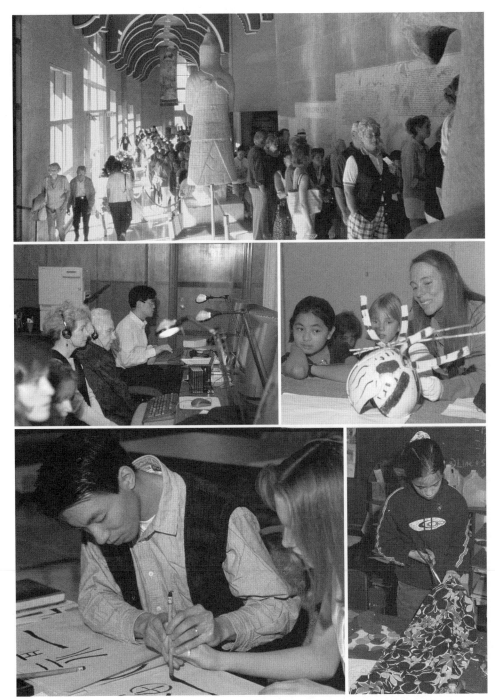

1. Museums are places where communities gather to learn, debate, share experiences, socialize, and be entertained. Here, visitors gather on the staircase of the Seattle Art Museum. 2. The museum's successful Ann P. Wyckoff Teacher Resource Center, developed in consultation with educators, provides free access to multidisciplinary learning materials. 3. As part of *Growing Up with Art*, local sixth-graders helped SAM's curators choose objects for the "Documents International" exhibitions, providing staff with "fresh perspectives on works of art." Photo by Paul Macapia. 4 and 5. Artists-in-residence Frederic Wong (left) and Hannah Salia (right) helped students create visual representations of the concepts they learned from museum staff. Photos by Paul Macapia (Wong) and Richard Nicol (Salia). ©Seattle Art Museum.

would value museums as places for rewarding intellectual and emotional engagement with art, not just as places for passive viewing.

Building this relationship meant introducing new programs and practices. The museum worked with teachers to design a four-year partnership with six Seattle public schools called Growing Up with Art, which became a testing ground for assessing student learning, expanding services to teachers, and inviting diverse viewpoints on the collection. Growing Up with Art centered on developing a museum-based arts education program for grades two through six, linked to state standards. Each year for four years, students and teachers from a coalition of four elementary schools and two middle schools participated in teacher workshops, artist residencies in the classroom, museum visits, and student-organized exhibitions. Both the elementary and middle school programs were linked to the social studies curriculum, with language arts integrated through writing. A major component—and a first for the museum—was a built-in strategy for assessing student learning.

Museum staff involved teachers directly in Growing Up with Art, so that curriculum and services were a joint venture. Teachers developed the learning goals and gathered the information that guided student assessment, and they planned artist residencies and museum visits. As part of the project, the museum opened the highly successful Ann P. Wyckoff Teacher Resource Center—also developed in consultation with educators—which provides free access to multidisciplinary learning materials. To ensure teacher involvement, the museum provided honoraria for attending workshops. In one middle school, the museum paid for substitute teachers for the time regular teachers spent away from the classroom.

The experiment with Growing Up with Art led the museum in a fruitful new direction in its relationships with the educational community and with audiences in general. The curriculum materials and classroom interactions were successful and had a lasting effect on the museum's practices. But it became clear that the most effective strategy is working directly with teachers. "One of the biggest lessons we learned," says Jill Rullkoetter, the Kayla Skinner director of education and public programs, "was that our impact could be greater if our focus shifted to teacher professional development and providing resources for them to use in the classroom instead of sending docents, muse-

um educators, and teaching artists into the classroom to teach students." The Wyckoff Teacher Resource Center positions the museum to use that strategy. On a broader scale, the initiative stimulated the museum's commitment to an audience-centered focus. "It was our first multiyear, cross-departmental effort to target services and develop programs for a specific audience," Rullkoetter says. "It also gave us experience in working outside the museum and with a specific community to accomplish mutual goals."

"Since the conclusion of Growing Up with Art, the partner elementary schools have structured their current artist residencies using the lesson planning model," says Kathleen Peckham Allen, former manager of school and teacher programs at the museum and now an arts education consultant working with the partner schools. "They have also made cultural organization connections an integral part of the residencies." In addition, several teachers from the elementary and middle schools partners joined an Educator's Advisory Committee at the museum, and they continue to involved the museum in their curriculum development and teacher programs.

ASSESSING STUDENT LEARNING

The museum began to develop lesson plans for teaching about its collections by looking for a big idea that applied to various cultures and could help the students relate art to real life. One year, for example, fifth-graders in the elementary school program connected African art to the concept of community roles. Guided by teachers, museum docents, and artists-in-residence—in the classroom and on museum visits—they learned how African societies use masks, dance, and music to help solve community problems. The students created masks and movements that expressed their own roles, and then they held a community event to show their families what they had learned.

From the big idea, the educators distilled concrete learning goals that they could measure. By the end of each year, they had specific, measurable data about the program—which lessons were successful in terms of student learning and which needed more work—because learning assessments were embedded into each lesson. This strategy was a significant result of the Pew initiative that the museum has since applied across the board in programming for students and teachers.

When the project began, however, the museum was on a different track. Staff had ambitious plans to assess and evaluate "everything, including the kitchen sink," Rullkoetter admits. The post-project evaluation questions seemed reasonable at the time, but they were too diffuse—from the impact of multiyear programming on students' relationships with the museum to the effect of the sequential curriculum on student learning. "At the end of the first year, we were left with an unwieldy amount of documentation that mainly went under our desks in boxes." Evaluation confirmed that students felt positive about the program, the museum, and Asian art in general, but "we were looking at too much and not learning anything substantial."

So SAM redirected its approach by making the important distinction between program evaluation and learning assessment. "We needed to find out if children were learning what we were teaching," Rullkoetter says. "We had no idea if we were successful beyond exposing them to art. And we wanted to be held accountable for student learning in our programs." Beginning in the second year, every interaction between teacher (or artist) and student was guided by a formal lesson plan that defined learning goals and set assessment criteria—"how we would know what they knew"—and strategies. "We wanted assessment to be part of the learning process, not after-the-fact tests that measure learning," Allen says. Using these tools, the students' artwork, writing, performances, and interviews became evidence of learning. "By clearly defining up front what we want students to know, it's easier to look for the traits and dimensions of their learning and make learning equitable so that all children can understand the lesson."

Each lesson plan begins with a problem to be solved in a larger, real-world context and a generalization that lays out the overall concept of the lesson. The generalization is stated as a relationship based on a universal concept or understanding, helping to make the idea transferable to the student's lifelong learning. The learning assessment process is embedded in the next segments of the plan:

- ◆ Target learning: The two or three specific skills, techniques, or knowledge the student acquires and can demonstrate (what you want them to know or do)
- ◆ Assessment criteria: The traits and dimensions of the student's learning (how you know that they know or can do it; what specifically you will see)

◆ What the educator does: Teaching strategies for the museum educator, docent, artist-in-residence, or classroom teacher

◆ What the student does: The work the student undertakes to master the target learning and apply it in other contexts

◆ Assessment strategies: A checklist, rubric, self-assessment, peer review, teacher observation, or other strategy for assessing student learning

◆ Evidence of student learning: Concrete, measurable evidence, such as written work or art-making activity

The clear criteria gave classroom teachers, artists, and the museum solid, measurable results they could work with. At meetings each summer with the artists and at an all-day retreat with museum educators to plan the next year, assessment results were reported to inform lesson revisions and other actions steps. One participating artist confided to the staff when reviewing the assessment results from a lesson she had taught two years in a row that at first it was a struggle to believe that a student's art could be assessed. "It was their individual expression. How could I measure that? But now I focus on one or two key concepts and the students can demonstrate those ideas visually. They know what they know. I know what they know. It makes all of us feel more confident about the learning in the arts."

In the middle school program the students learned the skills of observation, research and building personal interpretations by closely analyzing objects in the museum's permanent collection. The results show that a museum-based curriculum can indeed be a concrete, meaningful learning experience that strengthens these important life skills.

The model for writing lesson plans has been incorporated into the process of creating materials for teachers about special exhibitions and the permanent collection. Another area that has been affected by the notion of learning objectives is docent training. New museum docents are being taught to plan their tours around specific objectives related to a "big idea" they want the students to learn. "Docents are finding it easier to organize their tours," says associate museum educator Anne Pfeil, "and they are becoming more effective teachers." A third area of impact is the interactive learning spaces for families developed for some of the museum's special exhibitions. Beverly Harding, former manager of youth and family programs, developed a hands-on learning gallery

for an exhibition of paintings by John Singer Sargent. She explains: "I articulated two target learnings that I wanted all visitors to understand to help them interpret Sargent's work: first, a dynamic gesture can describe movement in a figure, and second, a sitter's attitude can express the relationship between the sitter and artist." Discussions with staff and written comments in an open-ended survey confirmed that kindergartners through adults grasped the key concepts and applied them to other experiences they had with art.

INVITING STUDENTS INTO THE MUSEUM EXPERIENCE

As part of Growing Up with Art, the museum staff wanted to experiment with sharing the authority for presenting the permanent collection by involving students in the decisions curators make when organizing and designing exhibitions. They decided to take a radical step by inviting sixth-graders from the museum's partner middle schools behind the scenes into museum storage areas to select objects and organize two exhibitions in a series called "Documents International." "Involving students in the fabric of the museum energized the staff and provided fresh perspectives on works of art," says Gates. Organizing and designing exhibitions is a coveted role within a museum that requires years of special training and knowledge, so giving young people this kind of direct experience required the suspension of some tightly held assumptions about who holds the authority when it comes to the interpretation and presentation of works of art.

The first student-curated exhibition, "Reflections in the Mirror: A World of Identity," featured 43 objects from all areas of the collections. The students chose to paint the walls yellow and install a disco mirror ball for accent lighting. Some staff members and a local art critic were dubious, but the audience, especially from other student groups, appreciated the fresh perspective. One student commented that "sixth-graders speak the truth. They say what they see and feel, they are honest and relevant." A museum moving toward a mission of "connecting art to life" hoped for exactly this response.

By the second exhibition, SAM staff had narrowed their focus to a few specific learning outcomes based on comparison and theme development. "Eleven Heads Are Better than One: Sixth Graders Connect with SAM" presented 36

pairs of objects exploring themes such as spirituality, adornment, and power through comparisons of Asian and non-Asian art. By creating unusual juxtapositions, such as Andy Warhol's *Double Elvis* and a Chinese guardian figure, and writing their own labels that were installed with the objects, the student curators brought fresh personal viewpoints to the objects. Visitors had a positive response to the exhibi-

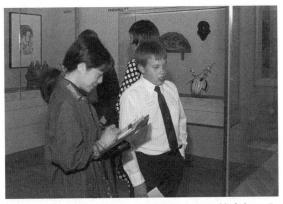

The student-designed "Reflections in the Mirror: A World of Identity," featuring yellow walls and a disco mirror ball for accent lighting, was a hit with the public. Photo by Paul Macapia. ©Seattle Art Museum.

tion, and evaluation results made the staff confident that alternative voices can be well received in the galleries. The experience also inspired *Create Your Own Exhibition*, a 10-lesson unit for grades 6 through 12 that uses visual analysis and comparison to study Asian and African cultures, and *My Art Gallery*, a lively Web site where kids can create virtual exhibitions (www.seattleart museum.org/myartgallery).

The debate over authority persists within the museum. While Gates is enthusiastic, some of the curatorial staff have been skeptical of approaches like the student-organized exhibitions. The exhibitions have not continued, but Gates explains that they had a noticeable influence: "The exhibitions established a crosscultural direction for installations. Once SAM expands in 2007, we will again have gallery space to accommodate student-organized shows based on the permanent collection." Some surprising and challenging cross-cultural interpretations emerged as the students analyzed, researched, and selected objects from different parts of the collections, developed exhibition themes, and wrote labels and text panels. Now, cross-cultural, cross-disciplinary possibilities for exhibitions based on the permanent collection are emerging more regularly than they might have before the student exhibitions. A current initiative to deepen relationships with African-American and Asian-American audiences, funded by the Wallace Foundation, also is informed by the exhibition experiment, which invited a particular audience to make critical judgments and share its diverse perspectives.

TOOLS FOR TEACHERS

It is one thing to encourage educators to use museum resources in the classroom, but it is quite another thing to offer convenient, one-stop access to a wide selection of information and materials. Perhaps the most significant result of the Seattle Art Museum's Pew initiative was the creation of the Ann P. Wyckoff Teacher Resource Center, which is the thriving live and virtual hub of the museum's professional development programs. The "live" center is a lending library at the Seattle Asian Art Museum in Volunteer Park and at six satellite locations throughout Washington State. Its virtual side is a searchable catalogue on the museum's resource-rich Web site for schools and teachers (www.seattleartmuseum.org/teach). Although other museums have mechanisms for lending curriculum guides, slide sets, books, videos, CD-ROMs, and other teaching materials, Seattle's resource center is particularly extensive and accessible, and it includes culturally diverse and interdisciplinary materials not available from most school district libraries and media centers.

The museum defines "educators" broadly, and a free membership in the resource center entitles any educator—including parents—to special services, teacher workshops, and open houses. Educators can browse the searchable online catalogue from the classroom or from home and choose teaching materials by format, topic, grade level, and curriculum. Then they can drop by the center during its open hours on Thursday, Friday, and Saturday to use, borrow, or copy resources. Volunteers help with special requests, and computers, slide scanners, color printers, and a copy machine are available. Through the satellite locations, outreach suitcases filled with touchable art objects and curriculum materials are distributed to educators through schools, libraries, arts associations, or PTAs. Elsewhere on the "Schools and Teachers" Web site, exhibition-related curriculum guides and classroom activities may be downloaded. There is a growing selection of thematic sites with interactive games, art tours, and curriculum activities.

Jill Rullkoetter remembers that the Internet was not yet a way of life in 1996 when the museum began its Pew initiative. Growing Up with Art inspired (and funded) the museum's first Web venture—an education site for access to Teacher Resource Center materials and other resources. That site was so successful that it led to a full-fledged online presence for the museum, which has been expanding ever since.

The number of active borrowers increased by more than 400 percent during the center's first two years. By the end of fiscal year 2003, 2,900 registered educators represented 172 school districts and 29 counties. More satellite centers are under development, and the substantial collection—some 2,400 items—continues to grow based on educators' needs and requests. The center's future operation is secure. An endowment campaign completed in 2000 raised $2.4 million for education, including a $500,000 challenge grant from the National Endowment for the Humanities (SAM was one of only two art museums to receive NEH challenge grants that year). The center was named to honor a large gift from a matching donor. Even in a period of retrenchment as the museum weathered the subsequent economic downturn, the teacher resource center was unaffected because of its endowment support. Now, the biggest challenge is keeping up with educators' increasing demand for resources and dealing with the limits of physical space.

Twice a year, once at SAM downtown and once at the Asian Art Museum, the institution hosts a well-attended teacher open house. Often timed to coincide with the opening of a major special exhibition, the event gives teachers the opportunity to enjoy themselves and learn about future installations, exhibitions, and programs well in advance so they can plan their lessons accordingly. Since Growing Up with Art, the museum has hosted summer teacher institutes and become involved in an intensive workshop program with the University of Washington Center for the Humanities and Seattle Arts and Lectures called "Teachers as Scholars." In addition, an educators' advisory committee meets quarterly with the education staff. Its members have become "master teachers" who will serve as mentors and share successful strategies for using museum resources in the classroom.

Embarking on an Audience Focus

By the conclusion of Growing Up with Art, the museum was serving between 40,000 and 50,000 students each year—almost double the number in 1996. "We have moved from having a very small, somewhat insignificant relationship with the schools to one that is much broader, more important, and sustainable," Rullkoetter says. "Within the institution, it is a program that will always be there." But the value of the initiative extends beyond its original

goals. By testing the possibilities with one audience—teachers and students— the museum staff gained the confidence and the enthusiasm for building connections with others. Some developments since the initiative ended in 2000:

◆ With a grant from the Wallace Foundation, the museum has begun to move from inconsistent, episodic attempts at outreach toward stimulating deeper participation by people who do not typically visit in large numbers, particularly African-American and Asian-American audiences. A major step in this project, called Deepening the Dialogue, was the creation of a new full-time position, director of community affairs.

◆ A new mission statement emphasizing audience and community links the museum's three sites—downtown, the Seattle Asian Art Museum, and the waterfront Olympic Sculpture Park (set to open in 2006)—as "a welcoming place for people to connect with art and to consider its relationship to their lives." A major expansion of the downtown museum—designed by Brad Cloepfil, founder of Allied Works Architecture of Portland, Oreg.— will open in 2007.

◆ A new curatorial team is dedicated to infusing exhibitions with audience-centered values.

"The museum's program will link audience to exhibitions, artists to communities, the permanent collection to special exhibitions, each museum site to the others," Rullkoetter explains. "Despite the economic climate, the museum is full of creative vitality."

Inviting Student Engagement

UNIVERSITY OF CALIFORNIA, BERKELEY ART MUSEUM AND PACIFIC FILM ARCHIVE

A university museum's primary audience is constantly in flux. Students come and go, and during their years on campus they juggle busy academic schedules with a wide variety of leisure activities. At the University of California, Berkeley Art Museum and Pacific Film Archive (BAM/PFA), for example, student attendance was not impressive—just 11 percent of the total—and the museum had limited collaboration with university faculty. So it launched an intensive, multifaceted effort to become an integral part of university life, involving students in the creation of more programs and activities for the campus community and encouraging faculty to incorporate museum resources—including the collections, exhibitions, and artist residencies—into their teaching. "We needed to be more visible and more accessible," says Associate Director Stephen Gong. The museum also had a long-term goal in mind: "We believed that if the art museum and film archive were a meaningful, relevant part of the students' college experience," says Gong, "then the arts had a good chance of remaining part of their lives in the future."

Staff members see a changed institution, with subtle differences in student, faculty, and staff attitudes and overt changes in programming and staff structure. Relationship building, which had not been a priority, is central to what the museum accomplished. Academic and student advisory committees link the museum to campus life. Two staff positions—academic liaison at the museum and outreach coordinator at the film archive—support faculty and student involvement. Artist residencies were expanded and adapted to meet the needs of students and faculty. A graduate student tour guide program was introduced. For the first time, the staff used audience research and marketing as tools for change. Digital media initiatives encouraged student dialogue about art and film. A new, widely marketed admissions policy makes the museum free to students, faculty, and staff. New and eye-catching signage gives the museum and film theater more visibility and a livelier, more accessible image.

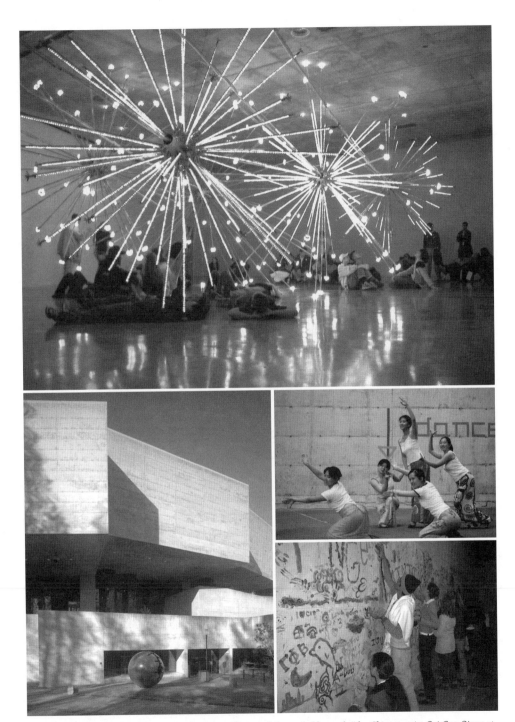

(Clockwise from top) 1. Students get close to an installation of electronic "fireworks" by Chinese artist Cai Guo-Qiang at BAM/PFA's "Pleasure Party." 2. Chinese Dance, a performance group composed of UC Berkeley students, performs at the museum's Fall Arts Fest. 3. Students take part in a giant finger-painting mural during "Pleasure Party."
4. The Pew initiative helped the museum, pictured here, become an integral, visible, and accessible part of university life.
©University of California, Berkeley Art Museum and Pacific Film Archive.

Yet despite positive developments within the museum and in its campus-wide relationships, the Berkeley experience illustrates a common conundrum for museums: What does success look like? If the goal is deep and substantive participation by a targeted group—not just increased visitation—what are the performance measures? "A university art museum can provide a student with a profoundly affecting experience; the deeper the engagement, the greater the impact," Gong believes. "The corollary lesson is that the deeper you make the experience, the fewer students you reach." Initiatives like Berkeley's require a substantial investment, but the return is difficult to assess. Artist residencies are especially resource-intensive, requiring substantial staff time for coordination. Although student attendance nearly doubled, from 6,600 in 1998 to 12,620 in 2003, the numbers the museum serves are fairly small. The activities that yielded the best results for Berkeley in terms of student engagement—student tour guides, student curatorial mentoring, new media team interns, and the student committee—involved relatively few students and a significant amount of time.

"By and large, we learned that there are few radical new discoveries that we hadn't anticipated, that the greatest changes are usually personal, intimate and internal," Gong says. The staff discovered that progress and change happen when the student voice is present, when faculty members are aware and involved, and when the museum staff is committed to flexibility, experimentation, and revision. "We knew we needed to encourage and use the student voice," Gong says, "and we clearly needed to work with faculty who could make [the museum] an assignment."

GIVING STUDENTS A VOICE

The University of California, Berkeley, has some 33,000 students, each of whom stays, on average, from three to five years. Preliminary research showed that more than 85 percent had seldom, rarely, or never visited art museums with school groups or their families. "Most of our students just don't know how to act in an art museum," says Gong. "They're not really sure what it is we do, and they find modern art completely off-putting." As a public university, Berkeley has a high percentage of students who are among the first in their families to attend college. "You can almost see the greater pressure these

students are under to make good on their education," Gong says. "They aren't likely to go to other activities."

As the museum staff considered how they could appeal to an audience with busy schedules and little inclination to participate, they realized that they could engage students on multiple fronts. "We usually think of students as a special audience that we want to reach, but there are other ways they interact as partners with the museum," Gong explains. As researchers, students can use the collections as a resource. As staff, they can explore career opportunities through work-study and internships. As visitors, they can enjoy the social experience of the museum and become better acquainted with art and film. "We wanted our students to leave Berkeley armed simply with the comfort of knowing that for the rest of their lives, no matter where they are, they can walk into an art museum or sit down to watch a film and feel at home," Gong says.

Reaching students required creating programs and activities not just for them but with them. A graduate student tour guide program, online tours of the collection led by student docents, digital media initiatives, and a student committee all link students with museum staff, with visitors, and with other students, leaving them with a fuller picture of the museum.

Graduate students from many different departments—not just art or art history—participate in the tour guide program. A different group of guides is trained to work with most temporary exhibitions, so there can be a special relationship between the guides' academic interests and the exhibition content. "Migrations," an exhibition of photographs by Brazilian photojournalist Sebastiao Salgado, attracted record-breaking attendance, including many visitors who could relate to the theme of mass migration. Student guides came from geography, political science, journalism, and other disciplines. One guide, who had just completed her dissertation on transnational migration between Mexico and the United States, gave a tour in Spanish for a group of Mexico- and Guatemala-born workers from a local painting and contracting company and their families.

Documenting the experiences of student tour guides was one aspect of the experiments in interactive media that were a dynamic feature of the museum's initiative. Student comments about several exhibitions can be heard in the

Conversations section of the BAM/PFA Web site (www. bampfa. Berkeley.edu/conversations). The student reflections also complement the continuing online exhibitions and serve as a recruitment tool for future guides. An artist residency inspired another media experiment, during which 24 students from a variety of departments—art practice, art history, molecular biology, cell biology, and others—worked with artist Valéry Grancher, Senior Curator Constance Lewallen, and Digital Media Director Richard Rinehart to create *24h00*, a work of Web-based art.

The student committee works with BAM/PFA's deputy director for audience development to raise student awareness of art and film programs and organize student social events, including a day-long open house in the fall to introduce the museum as a vibrant place that's fun to visit. This core group of students—which numbers about 15—has the closest behind-the-scenes connection to the museum, and some have decided to become interns. Members change every year, so Community Liaison Lana Buffington and committee member Olivia Barajas led the development of a manual that documents the logistics and procedures of student-to-student outreach. Now updated annually, the manual includes specifics, such as campus contact information and sample documents, along with some general guidelines applicable to other university museums. It has been distributed to the 32 university art museums on BAM/PFA's nationwide e-mail communications list.

A New Approach to Faculty Collaboration

At Berkeley, as at most universities, the art museum traditionally interacts with art-related departments—art history, art practice, film studies, architecture, and environmental design. "We knew that if we wanted to reach more students overall, we needed to move beyond those departments," says Sherry Goodman, director of education. By creating the position of academic liaison, the museum signaled the importance of integrated, long-term faculty relationships. Lynne Kimura's role is to encourage faculty to use the museum's collections and exhibitions as teaching resources—especially as the basis for assignments that bring students into the museum. Animal psychology professor Lucia Jacobs and her class met in the galleries during an exhibition on Asian elephants that have been taught to "paint." After meeting conceptual

artists Vitaly Komar and Alexander Melamid, they discussed a research trip to study the elephants' behavior. Jacobs says the experience "put into motion . . . an important art-science collaboration."

As visitors, UC students are invited to enjoy the social experience of the museum as well as become better acquainted with art and film.
©University of California, Berkeley Art Museum & Pacific Film Archive.

The artist-residency program has stimulated faculty involvement in the museum, and also illustrates the museum staff's own learning process. In charting the effectiveness of the residencies, Goodman notes, "it was evident that their appeal to faculty and students broadened each year as we successfully applied our earlier experiences." Year by year, the residency programs became more effective at fulfilling their goal of engaging a wide spectrum of students through exposure to art. The key lesson: A successful residency depends greatly on the interdisciplinary possibilities of the artist's work. "I think the essence of it was choosing the right kind of artist and choosing work that had interdisciplinary meaning," Goodman says.

When Roland Freeman was invited for a residency in conjunction with an exhibition of his work, university faculty clearly appreciated what he could offer their students. "Mule Train: A Journey of Hope Remembered" commemorated the 30th anniversary of the 1968 Poor People's March on Washington, which Freeman had documented as a young photographer. As the museum's education department began to spread the word, faculty in history, photojournalism, ethnic studies, and other areas signed on to participate. Other interdisciplinary residencies have included Fred Wilson, who arrived on campus four months before the opening of the traveling exhibition "Fred Wilson: Objects and Installations 1985–2000." He worked intensively with a small group of students to choose objects from the collections of BAM/PFA and the Phoebe Apperson Hearst Museum of Anthropology for a "cabinet of curiosities" shown with "Aftermath," a companion piece to the traveling exhibition. The longer residencies are labor intensive for the staff and the artists, but they give the artists time to become part of campus life and have a deep-

er impact on students. The staff also experimented with one- and two-day residencies that provided some of the same impact.

Goodman observes that successful faculty relationships require persistence and planning. "With faculty outreach, you cannot just assume because you're having an exhibit on civil rights-era photography that the history professors will call your office and say they want to bring their students," she says. "You have to let faculty know way ahead and get them thinking about their curriculum. You need to work pretty intensively with them to get them to realize that the visual arts truly further their own curriculum aims." In the end, a familiar principle of partnership applies: consistent communications about the partners' respective aims.

In addition to working with faculty, the museum has established resource-sharing arrangements with campus entities that cut across departments and have resources to share. Some artist residencies have been sponsored in collaboration with the Townsend Center for the Humanities and the Consortium for the Arts. "You want to partner with like institutions that have to be entrepreneurial in a sense, that have to meet you halfway," Goodman says.

A LEARNING LABORATORY

After the first year of the initiative, Stephen Gong and Sherry Goodman admitted they were frustrated that the diffuse array of activities they'd launched lacked a coherent image and were difficult to manage. Pulling together staff from every department of BAM/PFA proved to be an administrative and communications challenge. The museum's evaluation consultants were concerned that there were too many programmatic pieces to juggle—some aimed at the broad student population and some designed for a narrower group. But the flexibility and extended timeframe of the initiative allowed the staff to revise expectations and correct missteps.

By the second year, Gong reported that "a clear and organic design" was emerging as the museum's staff discovered their focus: encouraging and utilizing the student voice. From then on, the initiative was a useful learning laboratory. In 1999, the World Wide Web was emerging as a prominent mode of

communication, especially among students, so the museum devoted time to developing its Web presence and establishing e-mail marketing and communications tools. As a sign of commitment to student and faculty involvement, two staff positions were created to provide more direct, personal access. The artist-residency structure also developed over time. When Roland Freeman was in residence, for example, faculty brought their students to the museum, where they met with the artist in small groups or with their full classes. This approach was a change from the first two years of the residencies, when the staff felt that it was important to get the artists into the classroom. Instead, students were more fully engaged when they came into the museum and into the artists' world. Key to this effort, of course, is working with the faculty to ensure that they appreciate the importance of art in their own disciplines and curricula and that they encourage their students to experience art directly and on those terms.

On the film and video side, the PFA hosted a 10-day residency with Brazilian video artist and ethnographer Vincent Carelli. For the past 20 years, Carelli has worked with indigenous peoples in Amazonian villages to conduct video-making workshops and collaborate on the creation of video documentaries. He appeared at three screenings of his work and worked with small groups of students to explore his teaching and media-making methods. The subject matter facilitated connections with an exciting range of departments, including Latin American studies, anthropology, and Spanish and Portuguese languages, as well as with students and faculty with interests in Brazil and its indigenous peoples.

Part of the staff's change process was learning how to operate more effectively within the university. Although the museum is literally half a block from the center of campus, the conceptual distance is much greater. "When you're in a university unit that does not enroll," Gong says, "you're not as important in discussions about the allocation of resources." The museum still must work to assert its value as provider of a non-instructional form of education, but its strong services for students and its developing relationships with faculty are a productive change.

EXPANSION CHALLENGES

A significant physical and organizational transformation is ahead for the Berkeley Art Museum. Concerned about the building's seismic stability, the museum is planning a new facility in downtown Berkeley, on university property at the western entrance to the campus and adjoining the city's Addison Street Arts District. This new visual arts center will require rapid programmatic expansion on a scale the museum staff has not experienced. Kevin Consey was named director in 2001 after having led a major expansion at the Museum of Contemporary Art, Chicago. The staff has expanded significantly, planning for the $80-million to $100-million capital campaign is under way, and changes in the board have been implemented to support immediate leadership needs. The museum is investing in increased cultivation and engagement of board members and donors, developing campus and community support, and implementing an audience development plan, which includes an institutional branding campaign and improved visitor services. Like any major expansion, the benefits are promising, but the challenges to staff and board are daunting.

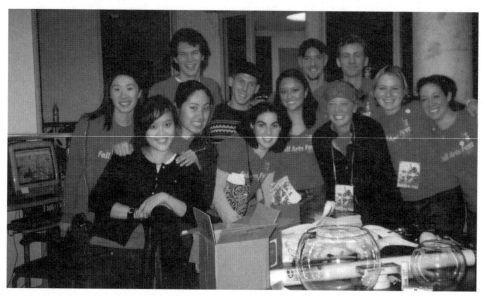

BAM/PFA's student committee meets weekly to organize a wide range of outreach activities and events aimed exclusively at UC Berkeley students. ©University of California, Berkeley Museum and Pacific Film Archive.

The staff anticipates that audience composition will change with the museum's move, as the location and face of the museum change from campus-oriented to public-oriented. Sustaining student services and student involvement will remain a complex work in progress, a consistent challenge that the museum staff has created the tools to meet. "We conceived the initiative in response to an identified need—the need to better attract new student visitors—and it turned out to be an extraordinary opportunity," says Consey. The Time of Your Life inspired some productive experiments—engaging directly with students, giving the museum a higher profile among the student population, bringing students together with artists-in-residence, and initiating relationships with faculty across a variety of disciplines—that will sustain the BAM/PFA's presence in students' lives.

New Audiences, New Directions

The drive to involve and expand its engagement with new audiences often is linked to the museum's desire to fulfill its mission. The five museums profiled in this section took specific steps to enhance and enrich the ways they actively involved, or expanded services to, specific audiences. This focused attention on audience led to innovative new programs and services that often were built from the museums' core programs.

These museums shared three characteristics: a focus on understanding and evaluating the audience; partnerships with libraries and community organizations to reach the new constituenc; and attention to involving the audience with collection. The audiences identified included Latino and African-American visitors, families, and teens, but each museum developed distinctive programs and services around its own collection.

The Museum of Contemporary Art San Diego identified its role as serving two nations and two cultures and learned through research that the Latino community was not participating in the museum. The changes have been profound and include fully bilingual information and resources, works added to the collection, public and educational programs, and community partnerships. The project also emphasized families as a core audience.

Recognizing that the local community was not actively participating in the life of the museum, the Museum of Art, Rhode Island School of Design developed a partnership with the Providence Public Library. The art bus Wheels of Wonder took art and reading projects throughout the state and brought the museum and library into new communities. Artist residencies created in partnership with public libraries involved community members and RISD students. These creative community-based exhibitions and installations helped to define a new profile for the museum, transformed the way the museum and the library support each other, and increased the involvement of RISD faculty and students.

The Minneapolis Institute of Arts conducted research that found that families and African Americans were underserved by the museum. Customer-service and diversity training led to a major changes in programs and services. Families are welcomed at the entrance with a Family Center that provides orientation and a place for active learning. Resources are available for touring the collections, especially for family learning. In addition, a newly diverse volunteer corps has helped to attract more African-American visitors.

The Denver Art Museum recognized that families were a central part of its diverse community and created permanent programs and resources throughout the museum. The focus on the family emphasized intergenerational learning and required the staff to create new programs and resources that teach about the collections. The museum's partnership with the library had more limited success due to differences in organizational culture and staff changes. Plans for an expanded museum building fully embrace the family focus.

The Whitney Museum of American Art involved teens as a core audience in the museum. In a yearlong program, teens become docents in the galleries and teaching partners in community centers. Bringing together talented and dedicated teens from throughout New York City to learn about the museum's collections required commitment and patience. Today the museum has dedicated staff and resources to maintain this in-depth and life-changing experience.

Art Across Borders

Museum of Contemporary Art San Diego

In a region defined by cultural and national boundaries, the Museum of Contemporary Art San Diego (MCASD) envisions art as a mediator. The community of this fast-growing region spans two cities, two nations, and two cultural traditions, which has led to both significant economic and cultural opportunities and longstanding tensions and divisions. "We are aspiring to reach the binational community in new ways," says David C. Copley Director Hugh M. Davies. "A museum, like ours, that focuses on the creativity and vitality of living artists is well positioned to link art and community, transcending boundaries and divisions to use contemporary cultural traditions as a unifying force."

With equal emphasis on art and community, the museum's Arte/Comunidad (Art/Community) initiative helped define a core vision for community engagement. Contemporary artists and their work—along with a respected collection, an active exhibition program, artist residencies, and community partnerships—are the connecting points. For 20 years, the museum has been solidifying its civic role in the region, which encompasses San Diego, the nation's seventh largest city, and Tijuana, Mexico, which is even larger—a target audience of more than 5 million people. As Arte/Comunidad began in 1995 (it was among the first four-year grants), the museum's downtown satellite facility had recently opened, and the main building in La Jolla was closed for expansion and renovation. "We were ready to move to the forefront of community and civic life, which is largely bicultural," Davies says. "And by 'community,' we meant the whole San Diego-Tijuana region. We knew by the early 1990s that we needed to make choices over the next 10 years that would reposition the museum."

Transformation has permeated the institution. When the initiative began, the staff used planning, strategic assessment, and evaluation to get to know muse-

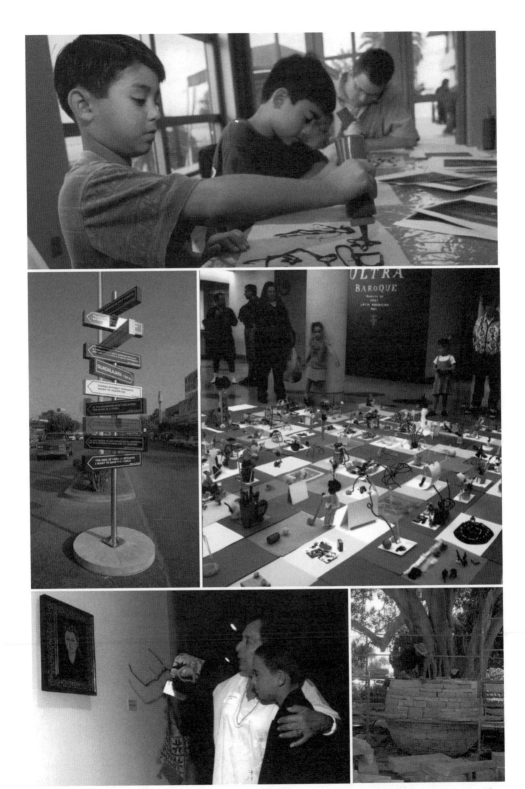

(Clockwise from top) 1. After viewing "Ultrabaroque: Aspects of Post-Latin American Art" (2001), young visitors used chocolate sauce to create works similar to that of artist Vic Muniz. 2. A Free for All program introduced families to the contemporary art in "Ultrabaroque." 3. Artist-in-residence Andy Goldsworthy installing his artwork in front of MCASD; photo by Philipp Scholz Rittermann. 4. Visitors enjoyed the artworks and timeline in "Frida Kahlo, Diego Rivera, and Twentieth-Century Mexican Art: The Jacques and Natasha Gelman Collection" (2000). 5. Marcos Ramirez ERRE's Crossroads (Border Tijuana–San Diego), 2003, a work he created during his artist-residency (aluminum, automotive paint, wood, vinyl; collection Museum of Contemporary Art San Diego; museum purchase 2003.8). Photos courtesy of the Museum of Contemporary Art San Diego.

um audiences—who they were, why they came (or didn't come), what they wanted to learn, and whether they valued their museum experience. Instead of relying on instinct, the staff acquired concrete data that contributed to informed decisions. A museum-wide vision made a difference, as did consistency of leadership; Davies and museum curators have long believed in a bicultural approach to exhibitions and programs. "We've learned that diversity must come from within before it can be manifested externally," says Anne Farrell, director of external affairs. "You need significant resources, sustained over a long period, in order to effect real change. Everything takes longer and costs more than you expect." When a museum steps up its community engagement, life can become more complicated.

A decade later, the museum's urban focus is taking shape as construction begins on a renovation and expansion project that will convert the historic 1915 Santa Fe Depot baggage building downtown into a museum that will open in 2005. With the existing MCASD facility across the street, the new museum campus will have 17,000 square feet of exhibition space, more than is available at the museum in La Jolla. "By tipping the balance to downtown, we foresee on the horizon new and deeper relationships with a larger community," Farrell says. "As MCASD has engaged with its community over these years, we've learned a lot. We'd like to think that the ground we broke with Arte/Comunidad and other community outreach programs helped set the stage for increased cultural engagement with the border issues that so define this region."

A New Vision of Civic Role

In the late 1980s, the artistic program at the La Jolla Museum of Contemporary Art, as MCASD was called then, was known for encouraging promising young artists and recognizing those whose work deserved more visibility. The board and staff were committed to the idea that the museum could develop into a vital cultural and civic asset, with contemporary art and living artists as the core. Since contemporary art often is grounded in real-life issues outside the formal realms of art or art history, they believed that it was an ideal connecting point with community organizations. By making the visual arts a figurative meeting ground, the museum could stimulate greater appreciation for the rich cultural traditions of the rapidly growing San Diego-Tijuana region.

The museum's artistic course began shifting to include more multicultural voices and present more exhibitions featuring Latino artists. As part of the large-scale multicultural program Dos Ciudades/Two Cities, funded in 1989 by the National Endowment for the Arts, the museum joined forces with a number of institutional partners (including the Centro Cultural de la Raza and the University of California, San Diego) on a series of community-based programs. In 1993, a major traveling exhibition, "La Frontera/The Border: Art About the Mexico/U.S. Border Experience," inspired new community programming and helped set the stage for Arte/Comunidad.

But the museum needed to overcome its elitist image, a tough challenge even with a visibly inclusive approach to exhibitions and programs. One problem was its location in the prosperous oceanside suburb of La Jolla, part of the city of San Diego and just a few miles from downtown, but worlds away in public perception. Although La Jolla is no more than 25 or 30 miles from most of San Diego's less-privileged urban areas, many city children have never even seen the ocean, much less visited La Jolla. Since most urban and rural schools have virtually no field trip resources, the museum decided early on to pay the cost of bringing students to La Jolla. Docents begin almost all school tours in the oceanfront sculpture garden, and the obligatory "Dear Docent" notes afterward often mention the experience of seeing the Pacific Ocean for the first time.

To bridge the geographical gap, the museum first established a series of store-front gallery locations in downtown San Diego, where it presented short-term exhibitions and public programs. In 1990, the museum was renamed the Museum of Contemporary Art San Diego, reflecting an institutional commitment to the entire region. In 1993, a satellite facility called MCASD Downtown opened in a 10,000-square-foot building across from the Santa Fe Depot, a prime location in the heart of the city, 14 miles from the border, and easily accessible by public transportation, including the trolley connecting San Diego and Tijuana. Soon after settling into its downtown space, the museum closed the La Jolla facility for a major renovation and launched Arte/Comunidad (Art/Community). These developments signaled an aggressive effort to make contemporary artists and their work—through a respected collection, an active exhibition program, and thriving artist residencies—the links between two cultures.

GETTING TO KNOW THE AUDIENCE

Arte/Comunidad was grounded in extensive research, ranging from "talk-back" mechanisms in the galleries to a community telephone survey. Demographic analysis revealed the composition of the museum audience and differences in visitor characteristics in La Jolla and downtown, information that would guide decisions about everything from museum hours to the development of interpretive materials. Visitor observations enlightened curators about small but important details, such as label-reading habits, use of audio tours, and exhibition traffic patterns. A telephone survey of 401 middle-income Latino households revealed that close to half had visited other San Diego museums, but not the Museum of Contemporary Art.

Museum staff say that what they learned about visitors affected their perceptions of how people use and value the museum and propelled them toward some significant changes in their own attitudes and practices. "Contemporary art can be a hard sell," Farrell says. "We sometimes must work hard to interpret art that might be abstract, conceptual, obtuse, or controversial." One important step was a museum-wide emphasis on bilingual services, including signage, orientation, and educational materials that helped make collections and exhibitions more accessible. Davies was among the first to enroll in the on-site conversational Spanish classes that all staff were encouraged to take. "Offering written and verbal interpretation in Spanish as well as English is a sign of respect as well as commitment," Farrell says, "and has helped build a loyal and repeat-visiting audience."

Exhibitions at MCASD are far more responsive and accessible today because of what curators and educators learned about public attitudes and perceptions. Extended explanatory labels, bilingual text and publications, and increased family programs are regular features. Aiming for deeper change in the face and image of the museum, marketing and public relations efforts target Latino audiences. Curators know that the community will be drawn to the museum by a more diverse permanent collection, so the museum has an ongoing commitment to acquire more work by artists from Mexico and Latin America, adding 214 such artworks since 1989. The museum also has increased its presentation and acquisition of works by regional artists, a change that has had a positive effect on the local arts community. A new exhibition

series, the Cerca Series, provides a fresh, up-to-the-minute view of emerging and under-recognized artists who live and work in southern California. The fast pace and short lead time of the exhibitions—each is installed for six weeks, with none scheduled more than one year in advance—allows MCASD to respond flexibly to new artistic developments. Most important, the museum is successfully provoking interaction among artists, museum visitors, and downtown denizens and has had an exceptional response from young adults. Every Cerca exhibition opens with an MCASD Thursday Night Thing (TNT), a monthly evening event that has attracted as many as 800 young people at a time from both sides of the border, belying the presumption that this "twenty-something" audience is not interested in museums.

SHARING CREATIVE PROCESS

A contemporary art museum has the advantage of relationships with living artists who can be intermediaries between the museum and the public, helping to demystify the creative process and engage people in art first-hand. MCASD's artist-in-residence program dates to the 1960s, and the goal of Arte/Comunidad was to broaden its scope. "Artists can be great communicators," Davies says. "They help us bridge gaps of language and culture." Some artists are better at interacting with the public than others, but museum staff noted that most were glad to have people observe their artistic processes. Artists were chosen first for the quality of their work, and then according to criteria the museum followed carefully:

- work that spoke to the realities of the bicultural and binational region
- the ability to work at the museum for one to four weeks, or the duration of the artistic process
- appeal to adult or youth audiences, along with the ability to communicate well with them
- an ethnic background that provides links to diverse communities

By the end of the initiative, 10 artists-in-residence had helped MCASD build new community connections as they offered teacher workshops, worked with high school students, gave bilingual gallery talks, visited an emergency shelter for children at risk, or collaborated with an alternative school. Some examples:

- African-American artist Gary Simmons created one of his "erasure" drawings in the La Jolla museum's Axline Court as visitors watched.
- Kenny Scharf, known for his graffiti style, created a major new wall painting—again in full view of the public—and taught a weeklong mural workshop for at-risk teenagers
- Marcos Ramírez ERRE, a regional artist based in Tijuana, created new works downtown and joined in a number of interpretive programs for teachers and the public.

The residency program remains a hallmark of MCASD programming and is a central component in the expanded MCASD Downtown. In 2002, for example, sculptor Andy Goldsworthy created a monumental stone "cairn" outside the La Jolla museum, almost literally on the sidewalk. In the weeks the artist was in residence, visitors and passersby were able to watch up-close as he created this massive permanent sculpture using only the most basic of tools. A number of local artists participated in the monthly Free for All Family Days program, introducing children and their parents to art-making experiences that help them better understand the work on view in the galleries. The first exhibition in the new space will be a commissioned work by Brazilian artist Ernesto Neto, who will be in residence during its creation and installation. In fact, the new downtown facility includes an artist-in-residence studio, and the museum will have ongoing international residencies.

When linked with the museum's community partnerships, artist residencies helped to strengthen relationships with community organizations. During Arte/Comunidad, San Diego-based artist Elizabeth Wepsic worked for three months with fifth-grade classes in two economically challenged Latino neighborhoods, teaching and making art. Students took field trips to the museum, where they toured an exhibition and learned about behind-the-scenes museum work. At the end of the school year, they unveiled their art projects—a student show and video at one school, a 40-foot mural at another.

ARTS PARTNERSHIPS

In 2000, the Museum of Contemporary Art San Diego launched its Arts Partnership Program as an extension of Arte/Comunidad. It is a structured program that invites nonprofit arts and community organizations in San

Diego-Tijuana to propose partnerships with the museum that create new programming in contemporary visual and performing arts. The objective is mutual benefit, and the partnering organizations must have complementary artistic purposes. "Partnership, in our minds, has evolved to mean the creation of something new, something that couldn't happen between two other parties, something that furthers both the shared and individual goals of both partners," says Kelly McKinley, former curator of education. "If a proposal doesn't fit that definition, we say no." A formal structure helps the relatively small museum staff manage their time and budgets, and it ensures a careful review of the pros and cons of the relationship. "We realized as more and more calls came in asking about joint efforts, that people really wanted a part of what we had," McKinley adds. "We were interested in them, too, but weren't really giving sufficient time to explore what it was that we could do together."

Recently, for example, the museum partnered with the La Jolla Music Society on an event that explored the influence of natural elements in the work of two artists: Tan Dun, a contemporary musician from China whose scores often incorporate the use and sounds of water, paper, and stone, and sculptor Andy Goldsworthy, who is also inspired by nature. The event began with a tour led by the museum's curator and featured a panel discussion with the curator and Tan Dun and a documentary film about the composer and his work. Other relationships also evolve naturally, and it is clear that there are mutual rewards. The museum benefited from its long-standing relationship with the San Diego Public Library—the library director, Anna Tatár, was a member of the museum's Latino Cultural Advisory Council—when the two institutions collaborated on a major "see/read" promotional and education program in conjunction with the exhibition, "Frida Kahlo, Diego Rivera, and Twentieth-Century Mexican Art: The Jacques and Natasha Gelman Collection." Another relationship emerged when the San Diego chapter of the American Institute of Architects needed space to hold its lecture series, now presented jointly with the museum and offered to museum members. The AIA series will move to the new MCASD Downtown when it opens in 2005 in a building designed by architects Richard Gluckman and M. Wayne Donaldson.

The downtown expansion, which is part of an overall redevelopment of the urban core, is itself an example of community engagement and partnership. The museum met with nine civic and community groups on the building

design, which the city council approved unanimously in March 2003. This process ensured citizen involvement in a project that has created jobs, stimulated commercial development, and will soon result in a dynamic contemporary art museum for both residents and out-of-town visitors. The entire project resulted from a creatively crafted development agreement negotiated among the museum, the city government, the Centre City Redevelopment Corporation, Amtrak, and Catellus Corporation, a private developer.

CONSISTENT LEADERSHIP

Hugh Davies took an early and active role in the Pew initiative because he believed that the museum's future viability depended on its repositioning as a vital cultural asset in the binational San Diego-Tijuana community. Small changes made a difference—an expanded schedule of interdepartmental and general staff meetings, weekly on-site Spanish lessons for any staff member willing to commit the time and energy necessary to learning conversational Spanish, and interdepartmental teams that encouraged thinking beyond organizational boundaries. The museum created a position of community outreach coordinator, working with the curatorial department to help implement MCASD's community relations program. Board development was part of the process, and the board now includes more Latino members as well as many younger, more community-engaged members. The museum is in the process of developing a new downtown advisory board that will engage the multicultural and business communities in the region and provide counsel and support for the expanded facilities. Staff changes are apparent, too, with more bilingual members (including two curators) and a more diverse staff. Davies emphasizes the role that Arte/Comunidad had in stimulating the museum's repositioning over the past decade: "We had the luxury of time and sufficient resources to experiment, to research our audience, to find new ways to make the museum relevant in people's lives."

Today the commitment to bicultural initiatives continues, despite the realities of funding a major new building, especially in a more difficult economic climate, and the inevitable changes brought about by staff turnover. Monica Garza, who succeeded Kelly McKinley as education curator, is beginning to

place her own stamp on the museum's current and future interpretive pro-grams for the downtown site. The board remains committed to community service, demonstrated in part by its financial support of such a significant expansion.

"One gratifying thing we have found is that the depth of community relationships—in particular with the artists and art community of Tijuana and San Diego—can help sustain an organization like ours, even in the face of fluctuations in financial support," Davies observes. The museum's long-term prospects changed dramatically in 1999, when it received a $30 million bequest from a trustee and her husband, Lela and Rea Axline. The endowment fund grew tenfold in just two years, making MCASD one of the best-endowed contemporary art museums in the nation—a transformative change that also poses major leadership challenges. "We want to sustain the artistic standards that have been built over two decades, and at the same time maintain our firm commitment to experimentation and innovation, to com-munity outreach and service," Davies says. "These commitments might be lost if we suddenly became a 'big museum' with a 'turnstile' mentality of name-artist exhibitions or blockbuster programming decisions."

Both artistic standards and the commitment to innovation and community will be evident in an ambitious exhibition that exemplifies the museum's 20-year pursuit of a bicultural, binational artistic and civic role. "Strange New World/Extraño Nuevo Mundo, Perspectivas desde Tijuana" will open in 2005. It surveys the developing Tijuana arts scene, capturing the energy of the city's young generation of artists, architects, filmmakers, musicians, and scholars. It is the first major U.S. museum exhibition dedicated to the creative vigor of this distinctive border city. "We'd like to think that the ground we broke with Arte/Comunidad has led to exhibitions like this one, which expand on our artistic and civic commitments of the past two decades," Davies says. "It helped us set the stage for increased cultural engagement with the border issues that so define this region."

Creative Harmony

MUSEUM OF ART, RHODE ISLAND SCHOOL OF DESIGN

Bringing artists and local residents together in lively and unconventional ways, the Museum of Art, Rhode Island School of Design sought an expanded community presence that would invigorate its programming. In an alliance with the Providence Public Library called Art ConText, the museum invited artists to create new works of art while in residence at neighborhood library branches. The potential benefits were many: for the museum, a larger and more diverse audience; for RISD students and faculty, a new view of art practice that highlighted collaboration in non-art contexts; and for the library, a more creative atmosphere and new patrons. In a broad institutional sense, Art ConText presented an opportunity to coordinate three elements of the museum that had not always worked in harmony: its encyclopedic collection, its role in training artists as part of the Rhode Island School of Design, and its public programs for diverse audiences.

Rebecca Belmore's photomural *on this ground,* created at the Smith Hill library branch, illustrates the complexity of Art ConText and how hard it is for a museum to sustain the benefits of a successful community-based artist residency. Over several months, Belmore worked with community volunteers and RISD students in a vacant lot behind the library, transforming it into a garden and creating a large-scale mural with images of hands in sand, objects from the museum's collection, and related objects from the neighborhood.

One beautiful late spring day, more than 250 people celebrated the unveiling of the mural. David Henry, head of education, describes the event as "Art Meets Weiner Roast . . . RISD students planted a community tree. Young people painted garden stones on tables next to the Wheels of Wonder artmobile. The librarian roasted hot dogs. Musicians from the neighborhood provided entertainment. And a Native American storyteller reminded the recent immi-

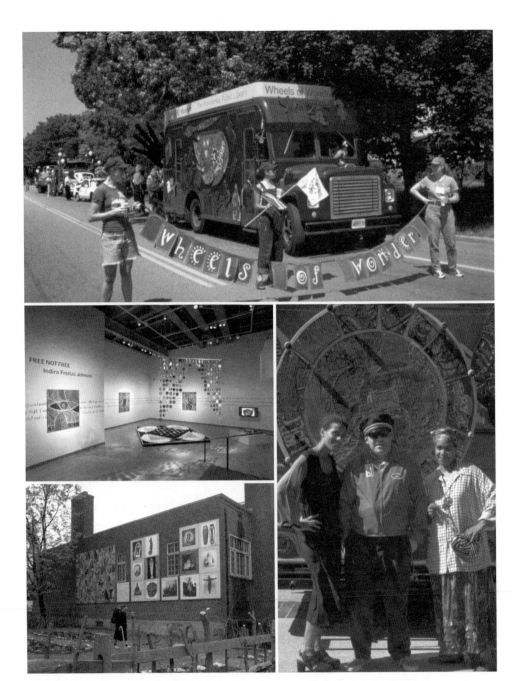

(Clockwise from top) 1.The Art ConText partnership led to the creation of Wheels of Wonder (WOW), a converted bookmobile that carried art and reading programs to more than 200 sites. 2.WOW driver/educator Frank Mapes (aka Artemis Bookbinder) with members of the Rhode Island Black Storytellers group; the bookmobile helped both museum and library establish a greater community presence. 3. With community volunteers and RISD students, artist-in-residence Rebecca Belmore created a photomural called on this ground on the wall of the Smith Hill branch of the Providence Public Library. 4. Indian-born artist and activist Indira Freitas Johnson worked with recent immigrants in a library-organized literacy class to create ceramic bowls representing acts of kindness. The bowls later were incorporated in her FREENOTFREE, an installation at the RISD Museum of Art. ©Museum of Art, Rhode Island School of Design.

grants who reside in the neighborhood (known as a 'Little United Nations') who the first people 'on this ground' really were." The mural attracted visitors from the neighborhood and beyond throughout the summer. The city donated garden benches, RISD classes came to visit, and the library asked for more images when the artist removed her mural in the fall.

Many Providence residents, says Henry, tend to see the museum as "a different planet, though it's only a five-minute drive." But the artist residencies helped to change that perception. For many people, seeing a practicing artist doing serious work on a daily basis demystified the art process. Though the 11 artist residencies do not appear to have built permanent museum audiences or boosted attendance, Art ConText had a different, "almost ethereal" impact, Henry says. "Art ConText has completely changed the museum. Our commitment to audiences, education, and contemporary art infects all of the museum's activities at this point, whether it is the exhibition schedule, fund-raising strategies, or our building project."

A TRUE PARTNERSHIP

The core of Art ConText was the museum's relationship with the library. It was a "true partnership," says library Director Dale Thompson. "We had had experiences with other organizations that were not as successful. Art ConText provided an opportunity for our patrons to meet and work with artists. This is not part of our regular experience, and it was a challenge." She attributes the project's success to intangible qualities: mutual respect, positive communication, collaborative problem solving, and leadership. In addition to the artist residencies, the partnership also developed Wheels of Wonder, a converted bookmobile that carried art and reading programs to more than 200 sites.

Libraries and museums are indeed different cultures, and finding common ground was an ongoing challenge. "The library's audience . . . better reflects the city we live in," Henry says, although librarians and artists working together was a novel concept. But as each artist made use of the library's role, the library became more proactive, assigning staff members to identify museum-library connections, thus strengthening both institutions' programs.

At the end of the project, evaluator David Carr highlighted the partnership's accomplishments as well as the goals that remain out of reach. Both the museum and the library experienced a greater community presence, which left the public with positive memories and a better understanding of contemporary art. The experience helped demystify the museum and deepen the library's role as a public forum. Museum and library staff met monthly to identify ways to maximize benefits of the residencies, consider new programs, and arrange schedules. The two directors consulted on occasion to discuss issues of mutual interest and reinforce the spirit of shared commitment that community partnerships require. As they worked together, the staffs shared a collaborative attitude, willingness to experiment, and a tolerance for variability and uncertainty.

The same variability also posed significant challenges. Each residency meant a different artist, library branch, and neighborhood and new RISD students, and it was up to the staffs to provide continuity. While many of the residencies introduced people to contemporary art, their effectiveness often seemed limited to a particular artist and a particular neighborhood. There was no sign that neighborhood residents became more inclined to visit contemporary art exhibitions or become regular museum or library visitors. Although the museum is in the central part of the city, "many people still associate it with the East side and college communities," Henry says. This outcome led to a significant realization: Just because people participate in a communal event presented by a museum, there is no guarantee that they will make the individual choice to attend the museum on their own.

Both the library and the museum staff would agree that one of the weakest links in the program was the lack of sufficient public relations and marketing to support the creative, original, and dynamic contemporary artists' projects. Local media coverage was especially hard to attract. "We came to know neighborhoods within our community much better, but the time and resources spent connecting with them cannot be maintained," Henry says. "We made good friends, but it will take a commitment of public relations and marketing to . . . give people reason to come back to the museum."

As for the library-museum partnership, it continues on a smaller but no less committed scale, even though the artist-residency program has come to an end, at least for the time being. The museum does anticipate having artists-in-

residence to complement exhibitions in the future. Worlds of Wonder, an art and reading program cosponsored by the library and the museum and an off-shoot of Wheels of Wonder, makes up to 100 school visits each year. The museum's relationship with the Rhode Island School of Design is stronger, too. "RISD is committed to making community and public art an integral part of its curriculum," Henry says, "and is using the library as a site for students to engage the public, a direct result of Art ConText that will continue to benefit the community." The initiative also introduced RISD faculty to library staff and resources, leading to new collaborative efforts.

TAKING NEW RISKS WITH ARTIST RESIDENCIES

Art ConText was the RISD Museum of Art's first artist-residency program, and it brought 11 artists to Providence to engage with the public, work with RISD students, and mount an exhibition of new art works resulting from these inter-actions. The program grew out of the conviction that artists have a powerful capacity to engage people in firsthand experiences with art. The education staff had to build alliances inside and outside the museum and become advocates for a program that was met with some skepticism because it expected so much from the artists: the engagement of an unfamiliar community in an unfamiliar place, the mentoring of RISD students, and the creation of museum-quality art-works. Doubts gave way to great enthusiasm over the works that the artists created. Two examples illustrate the rich variety of the residencies.

David Wayne McGee, an African-American painter from Houston, lived in Providence for more than four months. He set up his studio in the library branch in Olneyville, an economically disadvantaged, culturally diverse neigh-borhood about a mile from the museum. McGee chose portraits from the muse-um's collection dating from the 16th century to the early 20th century, and then painted Olneyville residents in similar poses and costumes. The museum's installation, *15 Minutes: The Ballad of Then and Now,* replaced the original paint-ings with McGhee's portraits. Instead of a 16th-century Italian monk, visitors saw McGee's portrait of a minister from Olneyville (who is also a museum secu-rity guard). The artist asked his 17 student assistants to meet one person with-in a two-block radius of the Olneyville library and create a work of art that related to the encounter. These works then were installed at the library.

Though McGee describes the community residency as "scary" for an artist who typically works in the isolation of a studio, he clearly thrived on the experience. "A lot of people say, 'What does the community get out of this?'" he says. "Are you being like Albert Schweitzer trying to do good?' It's not about that. It is about the greater good in ourselves—trying to make our art live in real space as opposed to the museum construct or the art school construct. It is not what I am giving to the community, but what the community gives to me. There is no 'high' or 'low.' It is just an even plain."

Indira Freitas Johnson's installation, *FREENOTFREE*, explored the question of how—in a free-market society where worth is determined by monetary value—we value "the countless acts of love, kindness, and support that are freely given and freely taken." Johnson is an Indian-born artist and activist whose passion for art as a vehicle for social change had involved her in arts-based community work in the past. During her Providence residency, she worked with recent immigrants in a literacy class at the Knight Memorial library branch, asking them to inscribe stories about their experiences with the kindness of others in ceramic bowls that they made in class. Johnson collected other stories in the community from Miss Fannie's Soul Food Kitchen, John Hope Settlement House, Dorcas Place Literacy Center, and from boxes placed in library branches and at the museum. The bowls were fired during a spring celebration on the library's front lawn. Neighborhood musicians and dancers performed, and Johnson painted a traditional Indian pattern (*rangoli*) on the library steps. She later incorporated the bowls into her museum installation.

When describing why she engages in community work, the artist describes her passion for "the challenge inherent in the process." Working with a group of people who may not know each other well, Johnson helps them discover "the commonality of our human experience and the spiritual potential inherent in all of us." The collaborative process involves constant power sharing and negotiation that ultimately "connects individual experience to the greater whole." Johnson says that the hardest part of the residency was traveling between Chicago and Providence, but she made the journey part of her project by photographing cloud formations from the airplane and incorporating them in her work. "The totality of the Art ConText residency was truly priceless," she says. "It reinforced my belief in the myriad bonds that exist between each of us and in the interconnectedness of all life."

The Art ConText Web site, www.risd.edu/artcontext, is a lively, interactive archive of the project. Each residency is documented in detail, with information about the artist, images and descriptions of the artwork, and stories about the individuals who were involved. RISD's Department of Film, Animation, and Video made documentary videos of the artists during their residencies. Interviews with the artists form an extraordinary record of their creative engagement with people in Providence neighborhoods and their resulting exhibitions at the RISD Museum.

A THREE-LEGGED STOOL

David Henry compares the challenge of the artist-in-residence experience to a three-legged stool. "The stool is often rickety, and the balance is very hard to maintain. With every project I have done here, the balance has been a little bit off in some way." The complicating issues were encountered not just at the RISD Museum, but at the other museums where residencies were part of the Pew initiative.

At RISD, contentious questions often arose over departmental responsibilities. Educators were making choices—about the selection of artists, the design of the artist residencies, and the presentation of exhibitions or acquisitions—that usually belonged to curators. "At first curators were a little threatened. There was a little loss of control," says Lora Urbanelli, former assistant director and now interim director. "By the fourth residency, I started hearing from the curatorial side about the power of the installations, about the profound connection to the community. They were really beginning to understand about community outreach not just being something that happened with little kids drawing on the floors of the galleries."

Boundaries between museum and community were challenged because the artists worked in multiple locations—in the museums, in their studios, and in libraries. Community members—library patrons, students, teachers, family groups, and others—often were involved in the creative process, and the challenge was to engage them in the creative process in meaningful but not intrusive ways. Boundaries between museum and artist were altered because the residencies had a social context that encompassed not just the making of art

but a visitor-centered, educational purpose. Artists and the museum had to negotiate the terms of their involvement because the museum became an active participant in the production and presentation of the works of art. Artist-in-residence Ernesto Pujol says that "the more a project seeks to engage and portray a specific community, to strive for community ownership of a final piece, the more the authorship issue has to be consistently negotiated in great detail throughout the process."

From the artist's perspective, Art ConText and artist residencies in general raised other questions. Pujol points out that using contemporary art to connect with new audiences is a risky proposition because it challenges traditional notions of art as "sculpture on a pedestal. So the first thing you have to do is to teach people what contemporary art is, long before you can use it as a recruitment tool." Pujol also cautions that exposing the artistic process—"the privacy of art making"—can border on exploiting the artist. "Where do you draw the line between having people participate in art making and kind of opening that process to the point where it loses its mystery?" On the other hand, he says, a project like this one has considerable meaning. "What this project has to offer is a chance for the artist to step out of the context of the art market and really have social impact. It reacquaints art with life, it reacquaints art with history, it reacquaints art with society."

Despite the considerable challenges, Henry says that each artist was committed to the complex multiple goals of working with the community, mentoring students, and mounting an exhibition. "This commitment, while not assuring magic, did [ensure that] the conditions for magic were present, and it did occur with regularity."

LOOKING TO THE FUTURE

Art ConText definitely has brought internal and external changes to the RISD Museum, says Henry: "Museum staff are more appreciative of and better able to work with living artists. RISD students and faculty have many powerful examples of the role of art in non-art communities. And thousands of people throughout the city and state have had meaningful firsthand experiences with the museum." A significant change within the museum has been the

108

Artist-in-residence Ernesto Pujol says that though there are challenges to working with the community, a project such as Art ConText "reacquaints art with society." Here Pujol discusses his installation Memory of Surfaces *with high school students. ©Museum of Art, Rhode Island School of Design.*

dynamic new emphasis on contemporary art, including the hiring of the first curator of contemporary art. Exhibitions of work by living artists, including Ernesto Pujol, Pepón Osorio, and other Art ConText artists, dominate the exhibition schedule. Teacher training now includes contemporary art, and a professional development initiative is under way. The museum has developed a consortium of high school teachers in partnership with the PBS four-part series on contemporary artists, *Art 21: Art in the 21st Century.*

The museum will have a new "front door" facing downtown Providence after the completion of a new building in 2008. The design by Pritzker Prize-winning architect José Rafael Moneo includes renovation of the existing building, with renovated galleries that will incorporate innovative learning spaces. When construction begins in January 2005, the museum will rely on off-site programming—including artist residencies and Worlds of Wonder—to sustain an active community presence.

Since Art ConText, the museum has expanded its view of what is possible as an educational resource and a community institution. A serious analysis is under way at the board level to explore how the museum can realize its public responsibilities more fully. A new mission statement has replaced the charter statement that had been in place since 1877, and it reads in part: "The museum, believing that art can make a significant difference in the human experience, strives to be a vital cultural resource for local and regional audiences, educating and inspiring artists, designers, and the general public." With Art ConText, the museum brought harmony to its multiple assets, so that art and community are now more closely linked.

New Forums: Art Museums & Communities

A New Audience for a New Century

MINNEAPOLIS INSTITUTE OF ARTS

Minneapolis prides itself on its tradition of civic involvement. In fact, Robert Putnam singled out the Twin Cities for their community spirit in his often-quoted book, *Bowling Alone*. Thus it is no accident that the Minneapolis Institute of Arts has dedicated almost two decades to strengthening its position as an inviting, visitor-centered civic space. For a major art museum supported by public funding, it is a natural thing to do. "We wanted to remove the barriers to access and enjoyment—financial, educational, and emotional," says Evan M. Maurer, director and CEO. "Why should the opportunity to have spirit-enhancing experiences be available to only a few?"

When Maurer became director in 1989, he was dedicated to making the museum better known and more accessible throughout the community. His leadership provided the momentum for change, including expanded education and outreach efforts, the pioneering use of interactive technologies in the galleries and online, and a free admission policy that helped increase attendance by more than 75 percent. Pew's 1995 planning grant came at precisely the right moment, underwriting a comprehensive two-year research and planning process that helped board and staff learn together about obstacles that prevented people from visiting the museum. This shared experience revealed the need for a wholesale change in attitudes and practices to make the museum a more welcoming place. Instead of asking museum-goers to adapt to established rules and customs, the staff finds out what they expect, need, and prefer and then reconfigures the museum's environment, programs, and amenities.

Introducing a stronger, more integrated visitor focus did not involve a radical shift for a museum with a historic commitment to education and public service. The most significant changes were sometimes subtle, and they involved communication and working relationships within the museum. For the first time, trustees, staff, and volunteers came together to listen to public percep-

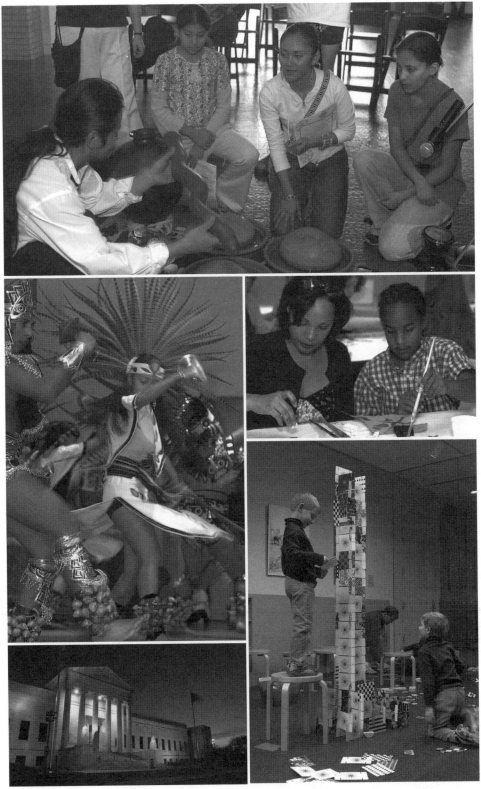

(Clockwise from top) 1. Children listen to a musician describe pre-Hispanic instruments. 2. Family Day visitors participate in a studio art activity. 3. The new Family Center delivers the message that "children are welcome"; here, young visitors build a House of Cards. 4. The Minneapolis Institute of Arts at dusk; the Pew initiative led to a shift in the museum's culture, from the board level on down. 5. Performers present an authentic Aztec dance during a Family Day event. ©Minneapolis Institute of Arts.

tions and shape strategies for change. "It was quite an accomplishment to bring all of these entities together so they would act as one unit. . . rather than as separate silos," recalls trustee Josie R. Johnson. When the museum reopened its significantly expanded and renovated building in the fall of 1998, a newspaper headline proclaimed that it had "made great strides toward becoming accessible to everyone."

AUDIENCE RESEARCH, AND MORE

The board and staff were convinced that despite the museum's accomplishments, a 21st-century institution needed not just continuing or augmented programs and services, but a visitor-centered climate that was apparent to people as soon as they approached the front door. The museum used its planning grant to launch A New Audience for a New Century, a focused research project designed to identify underserved audiences and develop a plan for attracting and serving them. But audience research and targeted marketing would turn out to be only the beginning of a noticeable shift in the museum's culture, from the board level on down.

Guided by experienced marketing professionals, the museum planned a multi-phase project. First the results of a comprehensive on-site visitor survey were compared with 1990 census data to determine who was not visiting the museum. The project team targeted two segments—African Americans and families with children between the ages of 5 and 12—and held focus groups to gather information about their perceptions of the museum. Next, trustees, staff, and volunteers from throughout the museum participated in two off-site retreats to watch videotapes of the focus groups and discuss how to proceed. This led to a significant change in the museum's communication and decision-making style. "Seeing with our own eyes what people really thought about us, and then thinking about what we would have to do to overcome those attitudes—that helped us begin to solve these problems," says Kate Johnson, chair of the education division. African Americans, for example, reported feeling isolated because they could not see themselves represented among the staff, volunteers, or even the works of art in the museum. Families were put off by the "don't touch" atmosphere and the shortage of services and amenities that ease the experience of visiting with children.

The project team had anticipated some staff resistance to the culture change they knew would be necessary to attract the target audiences, but their concerns proved largely unfounded. One curator remarked that the museum has an exciting opportunity to stimulate children's creative impulse: "Let's do everything we can to get them here and make that happen." A museum-wide sensitivity to many cultural traditions—including greater inclusiveness in staff and collections—would help make it more appealing to all people of color, other curators said. From these and other ideas that emerged at the retreats, staff from all museum departments developed a comprehensive marketing and implementation plan.

The next step was a customer-service training course for 130 staff and volunteers from every functional area of the museum. Customer service has a direct connection to museum success, and the museum viewed it as the essential foundation for what it wanted to accomplish. In the day-long sessions, participants learned about tested techniques for helping visitors feel welcome. They explored the connection between staff or volunteer behavior and visitors' comfort level in the museum—including the impact of their own biases—and used case studies, role playing, and other exercises to practice techniques they had learned.

A SHARED COMMITMENT TO VISITORS

Over the years, insights from A New Audience for a New Century have been integrated into the museum's operations. From the start, the staff's response was positive and proactive. The commitment to a visitor-centered focus is "a challenge for every single staff person because it permeates the organization," says Burt Cohen, a former trustee who now serves on the board's development and community committees. "It's programming, it's welcome signs, it's moving the labels down so kids or people in wheelchairs can read them." Establishing visitor-centered attitudes as a prelude to serving audiences more effectively was "a given at the board and the staff level," he says. After the audience research and marketing project, "everyone involved in the entire operation now had a mission."

The marketing plan outlined specific strategies for increasing satisfaction among African-American visitors and families with young children. Some

strategies involved changes in the physical environment and visitor amenities. For example, a redesigned entrance area is more welcoming and less confusing, especially for new visitors who need information or assistance. Front-desk staff make an effort to speak with every visitor, and large photos behind the information desk show people participating in a wide variety of museum activities. Easier-to-use maps and way-finding signage make the large museum building more navigable. A comprehensive series of self-guiding publications were designed and written so that families can use them together. Staff changes included a Visitor Service Team, a reorganized staff structure that is more consistent with a visitor focus, and an effort to make staff and volunteer groups more diverse.

The new Family Center, which is centrally located on the first floor, "has done more than any other single initiative to deliver the message that children are welcome," says Kate Johnson. The center is a place where parents, daycare providers, and informal playgroups can take a break from the museum, read books about art, eat snacks brought from home, play on kid-centered interactive learning stations, and view kid-oriented mini-exhibitions in low cases. The room has family-friendly amenities, including child-sized furniture, comfortable seating for adults, and easy access to family restrooms and the coffee shop. A play area with a cushioned floor allows kids to expend a lot of energy and get ready to be focused and reflective in the galleries.

A New Audience for a New Century also led to the establishment of the Collection in Focus guide program. Survey findings revealed that African Americans looked for something at the museum that "connected with my cultural heritage." So the museum staff recruited and trained 34 volunteers from the African-American community to give tours and lead discussions centered on the African art collection. Year by year, the program has expanded to include other segments of the collection and a diverse group of about 100 guides who are Asian American, African American, and American Indian; many have been trained to tour several areas of the collection, including European painting. Through Collection in Focus, "people who have no historic relationship with the museum are developing one over time," Johnson says. Training for this guide program is shorter in duration than traditional docent training and takes place in the evening, so that working people can fit it into their lives.

During the course of A New Audience for a New Century, the museum also put considerable staff time and energy into creating a teacher- and student-centered Web site in collaboration with the Walker Art Center. This joint venture, ArtsConnectEd (www.artsconnected.org) was funded by the state's Department of Children, Families, and Learning (since renamed the Department of Education) as a way to provide "one-stop online shopping" from the two museum collections. It continues to bring rich content about both collections into people's homes and classrooms, thus nurturing the next generation of museum visitors. More than 2,000 teachers have been trained to use ArtsConnectEd resources in their classrooms, and the two museums are continuing a program of paying teacher-trainers to train other teachers throughout the state.

THE LONG-TERM IMPACT

Six years after the New Audience for a New Century study, the impact continues. A 2001 strategic plan concentrates on two areas: building the collection and connecting with audiences. The plan explains that the museum will build on the accessible, visitor-focused experiences it has created to "strengthen and deepen that relationship with our key audiences and extend our impact with new and future generations." Families continue to be a focus of specific objectives and tactics. With funding from Ford Motor Company, the museum introduced Ford Free Sundays in 2002—an extension of the popular monthly Family Days featuring music, art-making activities, treasure hunts, and more. This expanded program has resulted in a 12-percent growth in attendance, and the museum is now open for more hours on Sundays.

With funding from the Institute of Museum and Library Services, the museum is conducting a study of visitors' response to technology-based resources in the building and on the Web. Kate Johnson explains that the data will be compared with the 1995 survey, continuing the effort to "identify what makes a museum visit gratifying for visitors, provide those things, and let people know these amenities await them at the museum."

Board and staff leadership are critical to the museum's ongoing dedication to be a visitor-centered institution. "Change doesn't just happen, especially in

Drumming during a Family Day program celebrating the arts of Africa. ©Minneapolis Institute of Arts.

museums," says Director Maurer. "It has to be driven." From the board comes enthusiastic support and strong leadership. "There's a confluence of ideas here," says Cohen, the former trustee. "We have the staff leadership, the board leadership, and the community environment to make this all work." The board is a highly involved board, and membership is much sought after in the community. In fact, attendance is so consistently high that there are rarely empty seats at the board table. "The board is more than supportive," Kate Johnson says. "The board demands, in a polite way, that the museum be responsive, be a contributor to the community, and be a leader."

In 2001, the museum repeated the 1995 visitor survey in an attempt to learn whether participation by African-American and family visitors had in fact increased. The results were disappointing because they showed virtually no change, even though overall attendance was increasing. While the findings might have been affected by the types of exhibitions on view or the fact that a special members' weekend was in process, they showed that counting the number of people who come through the doors is not the best way to assess effectiveness. Kate Johnson says that according to staff, more African-American visitors attend monthly Family Days or spend time in the Family Center, for example, and the Collection in Focus program is attracting enthusiastic new volunteers. Josie Johnson senses something even less quantifiable. "People of color are now more aware of the museum. It's not artificial. You don't feel like someone is putting on airs for you. There is a genuine interest in having people of color come to the institute in a variety of ways."

The "don't touch" atmosphere of an art museum—mentioned as a negative characteristic by focus group parents—is a drawback that the museum continues to address with art carts, "prop" bags, and participatory events. Even though the Family Center has been popular, "we need to do more to make the

museum family-friendly," Kate Johnson says. "Parents in our initial study also indicated they'd like more 'friendly people to answer my questions'—something that visitors of any age or any ethnic group would also welcome." Art Carts, staffed by Collection in Focus guides, provide opportunities for inter-generational learning and the conversations that lead to deeper connections with the museum's collections.

Based on the museum's experience in strengthening its visitor focus, there seem to be two criteria for innovation and change: leadership and patience. "If there is one ingredient that needs to be present in a healthy organization, and it has to come from the top, it is the creation of a safe environment in which to take risks," Kate Johnson says. Patience is a prerequisite because progress can be slow, and it does not necessarily have quantitative measures. The museum did not expect overnight success in attracting and satisfying visitors, and that was an accurate assumption. Inviting new audiences into a museum is not a finite project with benchmarks. It involves long-term change in entrenched institutional behavior and visitor perceptions. Perhaps the staff has changed the most, as a result of a teaming initiative begun in 2001 to encourage collaborative work on museum-wide issues such as visitor service, programming, and technology.

Construction is under way on a new wing for the museum, designed by Michael Graves and scheduled to open in fall 2005. Gallery space for special exhibitions and the permanent collection will increase by 40 percent, and along with the physical expansion will come greater opportunities for sharing art with as wide an audience as possible. The careful research the museum conducted as part of A New Audience for a New Century enabled it to put out a different kind of welcome mat. But perhaps more important, the project invited an inward look at the museum's aspirations for public service and the attitudes and behavior that determine whether those aspirations can be realized. As a result, the visitor experience at the Minneapolis Institute of Arts is valued, central to the museum's mission, and constantly developing.

A Family Focus That's Built to Last

DENVER ART MUSEUM

Every weekend, the Denver Art Museum hums with the laughter and conversations of adults and children who are immersed in art. Down on the floor in the Just for Fun Center, they're designing and building a playful child-sized chair inspired by one in the museum's design collection. In the Northwest Coast gallery, they're putting their heads together over a dugout canoe art project, pulled from the family backpack they borrowed when they came into the museum. All through the galleries, they're on the trail of Seymour, the family programs mascot, whose whimsical image marks the spots to find activities for adults with kids.

Like many art museums, Denver was known until recently as a first-rate place for adults with limited offerings for families—a large, diverse, and potentially loyal audience. Looking across the plaza to the Denver Public Library, the education staff wondered how they could emulate the library's seemingly effortless ability to attract family groups, help them feel comfortable, and make them want to return again and again. Some of these library patrons, in fact, did not even know that the tall building next door was a museum. Then the Pew Program for Art Museums and Communities entered the picture, and the museum had the time, the flexibility, and the resources to design an integrated approach to serving the family audience.

The Pew initiative was a natural next step for a museum that considers public confidence and participation to be major assets. In 1999, after Denver voters passed a $62.5-million bond to fund construction of a new building, gaining the public's support was even more essential. "Right from the beginning [of planning for our expansion], we needed to think of ways to make this institution more accessible and of value to the community," says Director Lewis Sharp.

1. In the *Just for Fun Center*, a matching activity based on the traditional shell game includes details from the objects in the Asian art collection. 2. Young visitors to the museum's *Western Discovery Library* try on costumes that match clothes worn by people in the paintings on display. 3. The Pew initiative helped the Denver Art Museum, whose new building is illustrated here, attract families, help them feel comfortable, and encourage them to return again and again. *Image by Miller Hare.* 4. Inspired by a Maya monkey pot, these young visitors to the Wackykids.org Web site printed, cut out, and hooked together this kid-designed chain of monkeys. ©Denver Art Museum.

The conventional approach might have been to create more live programs and classes for families and dedicate more funds to marketing—an option that the museum considered at first. But as the staff explored the possibilities, they realized that wholesale change, with a larger, more committed family audience as a long-term goal, would require something quite different: changes in the way the museum looks and feels. Melora McDermott-Lewis, co-dean of education and master teacher for painting and sculpture, describes how they got started. "As we watched the comfort of families sitting around the children's library relaxing and reading together, the warmth of the welcome they got as they entered the library, and the excitement they expressed as they took books and videos home, we knew that being more like a library for our family visitors would be our goal."

Over the four years of the Pew initiative, the museum invested in a sustainable infrastructure of permanently installed activities and services that are easy to maintain. This "hard copy," as co-dean of education and master teacher for Asian arts Patterson Williams calls it, grew out of research and experimentation. The staff mined the collection for objects, ideas, themes, and cultures with special appeal for families—which they defined as children ages 6 to 12 and their adult companions. Children's librarians from across the plaza inspired their thinking about space planning, program design, and customer service. They incorporated other ideas from children's museums, bookstores, and other places where families enjoy spending time. They experimented with new museum teaching models, tested activity prototypes, and revamped the design of public spaces. A "structured listening" component provided a better understanding of families' needs and expectations. The museum's unusual staff structure, in which curators and master teachers occupy parallel, collaborative positions, stimulated communication and enriched programming. Although the staff did not create the formal museum-library partnership they'd anticipated, they did develop useful professional relationships that continue to grow.

WHY CREATE A FAMILY-FRIENDLY MUSEUM?

When kids and adults came into the art museum from the plaza that faces the library's main door, they walked head-on into an environment that announced "adults only." One parent remarked that the museum felt "too hygienic" for

her children. "Our objective was to create an environment in which families can have memorable experiences with our collections, on their own terms," says McDermott-Lewis.

There were a number of good reasons to pursue families. For one thing, they make up about 40 percent of the Denver metropolitan community—a segment the museum needed to serve if it wanted to sustain public interest and confidence. Audience diversity was another motivation, because the museum has a predominantly Anglo audience in a region with a large Latino population. By engaging families, the museum could increase both attendance and audience diversity. The staff also wanted to be more competitive with the local children's and natural history museums, aquarium, and zoo—all of which, like the library, are more attractive to adults visiting with kids. Looking to the future, the museum counted on making lifelong visitors out of children who shared the experience with their parents or other adults who are important in their lives. And for many adults who are not comfortable art museum-goers, joining their children in a family-friendly atmosphere can make art more accessible.

SUSTAINABLE AND SIMPLE

Permanence, economy, and easy maintenance are the key characteristics of Denver's family activities. "Once we stepped back from grand programming ideas and looked at the nuts and bolts, we decided that it's more efficient to develop a finite number of activities and refine them as a 'core curriculum' for families than it is to come up with endless new kinds of projects," Williams says. At more than 25 places in the museum, there are 50-plus activities designed for families with different needs, interests, schedules, and attention spans. They involve varying degrees of commitment from participants and are suitable for different parenting styles. Most are independent activities, and none require planning or pre-registration.

The enticing menu of possibilities includes a family center, backpacks filled with art activities, Art Stops in the galleries, and the Kids Corner art-making space in the main lobby. Summer camps and staff-taught after-school programs in branch libraries incorporate many of the activities developed for families. A Web site for kids, www.wackykids.org, supplements the goal of making the museum a family destination.

Located in an open, light-filled area on the museum's concourse level, the Just for Fun Center is a colorful, inviting space designed for play. "Children have a different kind of fun than they would in the galleries, but they are still having an experience unique to an art museum," says Maria Garcia, head of family programs. "Kids can come down and piece together a giant Maya puzzle block by block, or just knock it down. That is something that never in a million years are they going to do in the galleries." Each of the seven easy-to-use activity stations has a direct connection to art and cultures in the collections. A matching game based on the traditional shell game introduces families to objects in the Japanese collection, for example, and "small world" play using magnetized animals and artworks highlights the Northwest Coast Indian art collection. Upstairs in the galleries, signs are posted to alert visitors to related activities in the family center on days the center is open.

Based on space planning and learning models gleaned from research and refined through formative testing, the space was intentionally located away from other visitor traffic. "We learned that there is a real need for families to have a space where they could let their guard down with no works of art around," McDermott-Lewis says. "And because the museum also needs to work for adults who come without children, we're able to contain the enthusiastic noise and chaos in the family center." The space appeals to first-time visitors because of its low-intensity introduction to art. "It's our 'starter program'—a place that's easy to enjoy and a place that many children want to revisit." It is also the place that the librarians are most likely to send families to start a museum exploration. When they walk through the door, the warmth and simplicity of the space communicates the message that the museum is not "hygienic" at all, but a great place for families.

Family backpacks, which date to the early 1990s, were assessed and expanded as part of the Pew initiative. They are one of the most popular educational offerings, and they have been so successful that other museums have adopted the idea. Hands-on, multisensory activities related to the collections are zipped into specially designed packs on nine themes. Visitors borrow the packs for free from a colorful custom-designed cart set up in the lobby on weekends and school breaks. A staff member is available to explain the options and help a family decide, for example, whether Western Adventure or Jaguars, Snakes & Birds would work best. Visitors carry these portable activi-

ty centers through the museum, using them as interactive guides for independent explorations of aspects of the collection. "A backpack is like having a teacher lesson plan," one parent said during a visitor panel that evaluated the program. "You have everything right here, and I find that's nice because then I can relax, and I, too, can learn." Visitor enthusiasm for the backpacks has been extraordinary; the number of visitors borrowing backpacks grew by 128 percent, from 5,564 in 1998 to 12,693 in 2002.

Portable Family Backpacks filled with hands-on activities encourage young visitors to explore the museum.
©Denver Art Museum.

All the family activities were created with minimal cost, and they are easy to maintain in-house. On weekends, the Just for Fun Center occupies an area used during the week as an entrance area for school tours. The furniture in the moveable activity stations was custom designed for the comfort of adults and children, and the graphic design of signs and banners is simple and vibrant. The cost of maintaining the activities is about $2,000 a year. The family backpacks are sturdy but inexpensive to replace, and shelves behind the backpack cart hold a variety of supplies for replenishing the contents. Commercially available software was used to develop the Wackykids Web site, which is simple and streamlined enough for the education staff to perform minimal updates. "We are slowly, slowly trying to expand it," Williams says, "but it is not as essential as our other family services and activities."

In addition to these new family offerings, the museum is known for the innovative gallery activities that it has incorporated over the last decade. Families wandering through the museum encounter two inviting Discovery Libraries— comfortably furnished galleries that are filled with works of art and resources on the collection. In the Western Discovery Library, for example, visitors can sink into a comfortable sofa to read more about the Western American art. Or they can learn more from interactive CD-ROMs, try on costumes that match clothes worn by people in paintings, or explore hands-on activities. American

Indian baskets and pottery, Western American bronze sculptures, and antique maps are displayed in different parts of the library. On Saturdays, visitors can handle objects at Art Stop stations in the galleries. Kid's Corner in the first-floor lobby is open daily for art-making activities.

To help other museum professionals learn from and adapt the Denver experience, the art museum has published a series of nine reports on the Family Fun section of its Web site, www.denverartmuseum.org. Every aspect of the museum's Pew initiative is described in detail, with a frank assessment of what worked, what didn't, and what the education staff learned about making the museum family-friendly.

STRUCTURED LISTENING

The museum consistently evaluates the effectiveness of exhibitions and programs for adults. With the new family programs, staff fully integrated formative testing into product and program development for the first time. "We decided that the purpose of structured listening—we stay away from the term evaluation because that's not really what we're doing—was to educate ourselves and inform staff thinking and staff development," explains McDermott-Lewis.

They focused on two approaches: visitor panels (a cross between focus groups and community advisory groups) and formative testing on the museum floor. Live programs served as creative laboratories for the development of independent family programs and the refinement of innovative teaching methods. Working side-by-side with families, educators tried out new gallery learning techniques, art projects, and synthesizing activities such as journal writing.

"We tested family backpack activities by watching visitors use them, seeing what happened, and asking whether it worked for them," McDermott-Lewis says. "If they it didn't, we changed it to make it work better." Seymour, the family program's mascot, was chosen in a weekend survey of visiting kids. Each activity in the Just for Fun Center also underwent prototyping and multiple revisions. And kids helped to test prototypes of the Wackykids Web site until it met the museum's goals.

Over time, the staff's structured listening confirmed that the most effective teaching model for families was playful collaboration rather than the traditional didactic approach—a departure for an art museum. They became experts at helping families learn by playing together and then closely integrating this approach with the collections. They haven't tried to answer the elusive question of whether family visits make a difference, and how. "In terms of our resources and what we wanted to accomplish, formative testing made more sense," McDermott-Lewis says. "Yes, it would have been nice to find out more about family learning, but the structured listening and the active prototyping actually did much more to change the institution."

A CREATIVE ENVIRONMENT

As the family focus developed at the Denver Art Museum, the culture of the museum clearly supported the people and practices that generated change. Director Lewis Sharp is committed to the notion that families round out the museum's public service and are critical to future public support and confidence, and he has worked to support and capitalize the education department's growth. Patterson Williams's reputation as one of the nation's most dynamic museum educators has helped to make the education department one of the museum's leading assets, and the museum's new family-friendly image reflects her intuitive understanding of the visitor, willingness to test new ideas, and enthusiasm for guiding and mentoring staff.

For more than 20 years, Williams has worked with McDermott-Lewis in a relationship that shares leadership, complementary strengths, and mutual support and was key to the museum's systemic focus on families. Now Williams is looking forward to her retirement from administration, and Sharp has selected McDermott-Lewis as her successor. They began sharing the position of dean of education in 2002. As planning progresses for the expanded facility, McDermott-Lewis has taken the lead, while Williams devotes her time to increasing "structured listening," collection-based issues, and her role as master teacher of Asian and textile arts.

As the museum builds a large and committed family audience—a process that is likely to take a decade—McDermott-Lewis has turned responsibilities for family

programs over to Maria Garcia, who visited the Denver Art Museum often as a teenager and, in fact, lived in the neighborhood. She began working there as a student intern, and the department's mentoring culture contributed to her professional growth. During a period of significant expansion, this emphasis on staff development, mentoring, and coaching ensures stability and consistency.

Williams was instrumental in the development of Denver's staff structure, in which each collection department has both a curator and a master teacher. This structure—perhaps unique among art museums—puts curators and educators on parallel footing in terms of responsibility and salary level. Interpretation of the permanent collection and special exhibitions is a joint effort by two experts who give equal time to the art and the audience. There are always rough edges to this challenging structure, which tends to depend on making hiring and promotion decisions that create the right partnership between two individuals.

"The curator-master teacher team approach really does work here," says Chief Curator Timothy Standring. "Does it work for every department? Maybe not, but we are going to be moving in that direction." Standring works with McDermott-Lewis. "We each bring our strengths to the working relationship. I bring an art historian's approach to the art, and Melora brings an understanding of the audience. When we go into exhibition planning, we really have continuing dialogue." Through their collaborative effort on the 2002 exhibition "Dutch Interiors in the Age of Rembrandt," they managed, in Standring's words, to "make the arcane accessible." Together they consulted with scholars and audience focus groups, and then put the results together. The process was "incredibly effective and we are using it for other exhibitions," he says. "Every group that I took through 'Dutch Interiors' said you get two shows for the price of one. You get to look at these great Dutch pictures, and you also get this wonderful story that really hasn't been told before. It really all came out of our collaboration—and teamwork, teamwork, teamwork."

Throughout the Pew initiative, interdepartmental teams of marketing, curatorial, and education staff maintained the visibility of new family programs and thought about how to deal with the museum's commitment to the family audience. Within the education department, the Family Program Initiative Group—representing the entire department's programming areas—became an

effective think tank, a communication group, and a staff development tool. It met once a month to analyze the program's strengths and weaknesses, develop further direction for individual program components for families, and consider larger issues of museum accessibility for families. Denver Public Library staff members were frequent guests, sometimes conducting workshops for museum staff. One of the most important results of the working group was the development of education staff members, like Garcia, who are firmly grounded in family education. Although the Family Program Initiative Group no longer exists, the learning and cooperation it inspired continues. Group members testify to the substantial increase in their skills, knowledge, and commitment to family audiences.

A Learning Partnership

The relationship between the museum and the Denver Public Library was envisioned as a true partnership with extensive joint programming and regular interaction based on leisure-time family learning activities. Instead, it turned out to be what could be called a learning partnership. Although they are close neighbors, the two institutions had not collaborated on day-to-day programs until the museum began its Pew initiative. Now staff members have working relationships that range from simply knowing more about who does what to developing cooperative programming. Williams says new professional relationships may be the partnership's most positive outcome. "When we have an idea or need some advice, we know we can pick up the phone and call a colleague at the library, and they can do the same. That sounds simple, but it's a major difference."

The library, whose mission is "to help the people of our community to meet their full potential," was a natural partner and community-based model for the museum. The library's family audience is much larger and much more culturally diverse than the museum's. Library patrons already have overcome issues of parking and access barriers, and libraries are not tied to the elitist label many people place on art museums. In visitor panels, the museum learned that some library patrons feel more secure and comfortable in the library than they do in the museum.

Together, museum and library created new initiatives and joint programming focusing, including art-making programs in the library, free museum admission for the library's family patrons via a special button distributed by librarians, and after-school programs in library branches taught by museum master teachers. But the principal outcome of the partnership was valuable shared knowledge about what makes visiting families welcome and comfortable. The museum staff learned that families want relaxing areas where they can sit together and share resources or do activities. In response, they developed the family center and expanded the family backpack program. They also found that the library is staffed on weekends with people who treat children with warmth, courtesy, and respect. Now the museum has weekend visitor services staff that provide a combination of hospitality, problem solving, and family advocacy. They have learned to keep the interactions with families as simple, direct, and welcoming as possible.

The greatest challenge to the relationship was staff turnover. Personal relationships facilitated collaboration, and over time, both the library and the museum learned that they were critical. Starting over with new staff proved to be a time-consuming but necessary element. The partnership was not as extensive or, on the surface, as successful as the museum had hoped it would be. But the subtle changes—mutual understanding, professional development, increased informal communication, and flexibility about starting new joint programs—are a start.

Beyond the Building Blocks

Like many of the other Pew museums, the Denver Art Museum used the gift of resources, time, and flexibility to experiment. Out of its learning "laboratory" came the building blocks for change. The immediate results included a museum that simply looks different. Family programs and services occupy prime "real estate," and adult visitors and family visitors comfortably share the gallery spaces. Instead of aiming for high-profile but ephemeral live programs, the museum invested in "hard copy" for long-term use. Scheduled programs and classes still generate earned income, but free, mostly independent family activities have been integrated into the museum's galleries and public spaces.

Now that this basic structure is in place, the museum has a foundation for the next step—creating a committed family audience. "We know this is something that won't happen immediately," Williams says. "In fact, it might take us a decade or even longer to show significant change in the size and diversity of our family audience." Family programs are likely to attract people who are comfortable museum-goers. But reaching another, much larger, audience will require another level of effort, which the museum is incorporating into its plans for the new building, designed by Daniel Libeskind.

The museum's vision statement for the next several years puts visitor experience at the core. "Our goal is to provide a unique experience from the moment visitors enter the museum complex," says Lewis Sharp. "We hope to create meaningful experiences—for art novices to experts alike—connected to the art, the architecture and other visitors." Just as the family center is a connecting space between library and museum, staff members have been brainstorming ideas for areas that link the two museum buildings and combine places to rest with enjoyable art experiences. Family programming has been part of the planning process from the start. All the familiar features—family backpacks, Art Stops, and integrated gallery activities—are in the works. Within the galleries, the environment will reflect the direction the museum has been headed over the past decade—opportunities for reflection, interaction, art making, and self-directed discovery, with a comfort level that suits families with children as well as adults.

A Place of Their Own

WHITNEY MUSEUM OF AMERICAN ART

Amy, a high school student in Manhattan, has made a meaningful discovery in the galleries of the Whitney Museum of American Art. "I once thought about museums as places for looking and observing," she says. "Now I think of them as centers for communicating." Through the museum's Youth Insights program, Amy joined young people from all parts of New York City to learn about American art, develop important life skills, and engage with peers, senior citizens, and families in a rewarding—perhaps even life-changing—intergenerational "conversation." Jackie, who attends high school in Jackson Heights, Queens, describes the essence of the Youth Insights experience: "Art is about '-tions': communication, interaction, interpretation, imagination, and creation."

A framework of educational programming supported the Whitney's initiative when it was launched in September 1997. Over the years, the museum had developed solid offerings for audiences of all ages. The education department also had relationships with a number of different community organizations. But like many museums, the Whitney hadn't developed intergenerational programs that would bring its audiences together. The staff deliberately designed Youth Insights for an intergenerational group whose collective experience would span two centuries. Six years and some 150 teen participants later, Youth Insights is a permanent program with a strong and vital presence and wide impact on the museum.

Raina Lampkins-Fielder, the Whitney's associate director for education, says Youth Insights "brings a wonderfully fresh and exciting energy to the museum. As an institution, we've made a real commitment to mentoring young people and giving them the skills to be successful communicators, critical thinkers, team players, and interpreters of American art and culture. These extraordinary young people work hard and learn a great deal, but their real

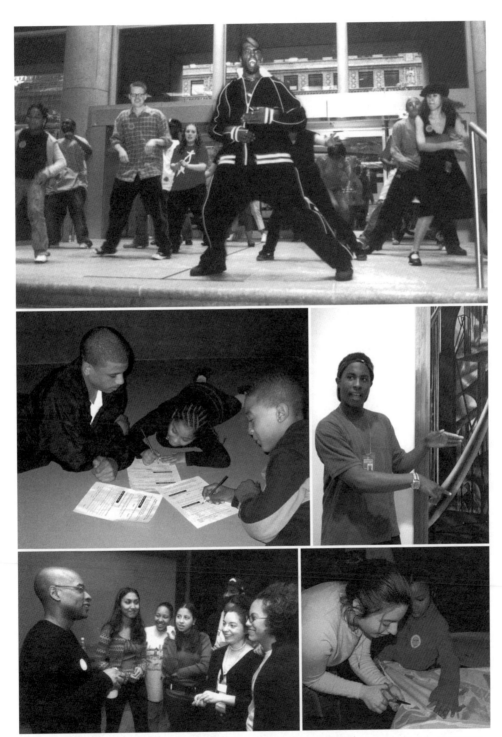

(Clockwise from top) 1. Teen Night, May 2003: a collaboration with the National Dance Institute. Photo by Quyen Tran. 2. A Youth Insights participant leads a Youth2Youth tour of "An American Legacy: A Gift to New York." 3. A child from the Regent Family Residence works on an art project, aided by a Youth Insights participant. 4. Artist Glenn Ligon chats with the museum's teenage "ambassadors" following an Artist & Youth: A Dialogue program. Photo by Jim Berry. 5. Trained in seminars conducted by museum staff, Youth Insights participants can talk about art with visitors of all ages. ©Whitney Museum of Art, New York.

contribution is to remind us that multiple perspectives—especially from different generations—enrich the experience with art."

Intergenerational Dialogues

At the heart of Youth Insights is a corps of 15 to 20 high school students who spend at least a year as the museum's "ambassadors." In the spring, candidates are recruited from New York City schools, four of the museum's community partner organizations that serve youth audiences, and other community organizations. After a competitive application process, the teens begin a rigorous 13-week training period. Seminars introduce them to the collection and to current issues in 20th- and 21st-century American art and culture. They practice communication and analytical skills that will help them lead gallery tours and facilitate dialogue about works of art with visitors of different ages. Behind the scenes, students meet with staff from various departments to learn about their professional responsibilities. They also visit artists' studios to observe the artistic process firsthand and talk with professional artists. The program requires a serious commitment of six to 10 hours a week during the school year and full time during summer vacation; the students receive an hourly stipend, transportation, and meals. Youth Insights participants know that they represent the museum. Back at their schools and community centers, it's their responsibility to spread the word among teachers and peers about the museum's resources and encourage people to participate in intergenerational programs.

Once their formal training is complete, Youth Insights participants are actively involved in programs for senior citizens, teens, and families—all audiences that the Whitney wants to serve more effectively. As a result, says Cathleen Lewis, former head of youth and community programs, "the program expands the museum's constituencies in a really brilliant way." Youth Insights challenges traditional practice by welcoming high school students' fresh perspectives and recognizing that they are fully capable of leading activities and projects. A diverse mix of people—young children, teenagers, adults, and seniors—learn from and with the teen participants, and from and with each other. Museum Director Adam Weinberg observes that "the energy that comes from this mix is extraordinary and helps us to re-evaluate the traditional divisibility of audiences by age and type."

Youth Insights programs for seniors are conducted mostly during the summer. The teen participants fan out across the city to senior centers, including those run by the museum's partner organizations, Dorot, Inc., and United Neighborhood Houses. They lead slide conversations and organize art projects, and listen with pleasure as the seniors tell stories relating art to their own experiences. They pose questions that invite the seniors to talk about their perceptions, such as "Have you ever seen a work of art and wondered why it is art?" Senior groups then come to the Whitney for youth-led tours and an opportunity for dialogue about art that is always lively, and sometimes even contentious.

With art as the meeting ground, the teens find impressive rapport with their elders. During a gallery tour, a woman tells her guide that Ben Shahn's *The Passion of Sacco and Vanzetti* reminds her of her husband's union days, when he was falsely labeled a Communist sympathizer. Coaxed into conversation about Willem de Kooning's *Woman with Bicycle*, another visitor admits that despite her intensely negative first response, she might actually learn to like the painting. When a young tour guide pauses to admit that he's lost his train of thought, a voice calls out, "He's having a senior moment." Sensing the group's warm support, the teenager relaxes with a smile.

Workshops for families are among the museum's most popular programs. Youth Insights teens work alongside museum educators in monthly Family Fun workshops, assisting with art projects and leading discussions with visiting children and adults. In the weekly Look Out! program, they give thematic sketching tours in the permanent collection galleries—tours they have researched, prepared, and practiced carefully. As adolescents and young adults, Youth Insights students can provide a unique link between parent and child in the learning process by making art more accessible and the museum environment more comfortable.

At a temporary housing facility for formerly homeless families, Youth Insights students are both teachers and role models. Every Thursday evening during the school year, they help Whitney staff and artists run the museum's after-school arts program at the Regent Family Residence, where some 200 children, ages 5 to 14, engage in arts activities and projects tailored to meet their special needs. Both the children and the Youth Insights participants benefit. "I

like working with younger people because it feels good when you know that they are listening to you, especially when they look up to you and consider you a role model," says Evie. Artwork created in the program is displayed at the Regent Residence, building the children's self-esteem and creating a lasting artistic environment. Just as Whitney educators often become mentors for Youth Insights students, the teens become role models for the younger children. In fact, two former Regent children are now Youth Insights alumni.

One of the most creative features of Youth Insights is its programs for teens, which bring this greatly underserved audience into the museum through peer-to-peer events that make the Whitney less intimidating and more engaging. "Some of the challenges we face in engaging new teen audiences have to do with the image of the Whitney Museum and its location on the Upper East Side of Manhattan," says Helena Vidal, assistant director of education. "We want to let teens know that it's possible to make the museum their own." Youth Insights programs for teens stimulate conversations about the relevance of American art, history, and culture to their own experience, reinforcing the personal, social, and professional rewards of creating and reflecting on art.

On the third Friday of every month, Youth Insights participants lead free interactive tours for other teens. These Youth2Youth gallery talks turn the traditional tour inside out, with the Youth Insights teens using what they've learned in the program to initiate the discussion. They also contribute to planning What's Up? At the Whitney: A Teen Night Out, a lively twice-yearly event that features dialogues with contemporary artists moderated by the teenagers, followed by an evening of music, dancing, and food. Teen Nights give the museum an opportunity to collaborate with youth-oriented arts organizations on spoken word, dance, and musical performances. Over the last few years, nearly 1,000 new teen visitors have come to Teen Nights; many recent participants learned about Youth Insights at this event.

Several times a year, Youth Insights participants facilitate dialogues for high school audiences with contemporary artists whose work is being exhibited at the museum. As they prepare for these intensive conversations, they hone their research and communication skills by learning about the artist and formulating questions that will make for a lively and provocative dialogue. Participants also meet with the artists in advance, visiting their studios to learn more about their

process. Conversations with artists about their work have a profound effect on the students, who are impressed that they can be both creative geniuses and down-to-earth people. The artists have been just as impressed. After a Youth Insights group visited his studio, artist Glenn Ligon said that he was "overwhelmed by the intelligence of the questions and comments" about his work.

The dynamic Youth2Youth Web site, developed in collaboration with the Center for Children and Technology in New York City, is lively and teen-friendly, and its focus and structure reflect Youth Insights' emphasis on dialogue and individual expression. The interactive "Your Insights" section features a virtual art gallery, discussion forums, and a bulletin board for participants and alumni. Youth Insights participants contribute short biographical statements, some with short videos.

A SMALL PROGRAM WITH BIG IMPACT

On the surface, Youth Insights affects a relatively small number of young people. But the program has a far deeper impact that makes it well worth the investment. "Youth Insights succeeds in its community outreach efforts perhaps even more so than a lot of other programs at the museum," says Cathleen Lewis. "We're getting kids from the Bronx, Queens, Brooklyn, and Staten Island. We're helping to knock down these imaginary boundaries between boroughs and between the museum and its surrounding communities." About the program's impact, she observes: "Will all of them turn out to be museum goers all their lives? Maybe not. But I think a lot of them will come back to the experience that they had here." Sydnee is just one student who confirms Lewis's instinct: "The Whitney is now that long-lost friend that I hoped for in the sixth grade. I do not know if I want to be an artist in the future, but I do know the Whitney Museum will always be that friend."

Evaluation played a big part in the Pew initiative and continues today. Using both formal and informal methods—including group discussions, interviews, questionnaires, process folios, and video footage—the staff involved the teens, museum staff, and program audience in an ongoing assessment that helped them make modifications. In the beginning, for example, senior citizens had no advance preparation for their visits to the museum, where they sometimes

encountered art that shocked them and did not want to return. Introducing a pre- and post-visit program has smoothed the way to a better experience. Program staff also worked with an evaluation specialist, Jessica Davis of Harvard University Graduate School of Education's Arts in Education Program, to assess Youth Insights's educational effectiveness and document its story and structure. For the four-year evaluation at the end of the Pew initiative, rich anecdotal information provided a "reflective description" that helped the staff evaluate and refine the program. Davis used what she termed "portraiture and ethnography" to observe and describe the program from various perspectives rather than offer an objective assessment of its success. Her thought-provoking report is filled with reflections by students and staff. Video documentation, made by staff throughout the project as a self-assessment tool, provides useful firsthand feedback.

The museum also conducts periodic assessments of the students' progress. Participants use videotapes of training sessions and practice tours to observe techniques and reflect on their own development as museum guides. Written feedback from students informs Youth Insights planning and the development of public programs. Recently, the education department has begun tracking participants' higher education and career choices through an alumni network as another way to evaluate Youth Insights' long-term effectiveness.

Youth Insights participants describe the program's impact in a variety of ways:

- "The most important part of Youth Insights to me is being able to learn through my peers about art forms and cultures that I wouldn't have normally been interested in. While I learn a lot from my own independent research, I always learn the most from other people recounting their own experiences and sharing their own thoughts."—Amy

- "Youth Insights has given me a sense of responsibility, a kind of learning experience that is not your basic scholarly education. It's very cool to come in and share with so many people. I enjoy working with all age groups, but adults are more opinionated than kids are when they talk about an artwork."—William

- "A year ago I was failing out of school. . . . My history teacher gave me a paper about this program. I have never felt more accomplished as I do right now. I feel like I have a million arms. It's not just a job. It's something that helped me piece my life back together."—Anonymous participant

For the museum, managing the presence of 20 young people was almost as challenging as establishing an identity for Youth Insights within the museum. At first, the teens felt unrecognized outside the education department and wanted more exposure to museum staff. Lewis thought the staff didn't fully understand the depth of Youth Insights, so in 2001 she began offering internships in other departments to selected participants. These in-depth experiences exposed the teens to real-life responsibilities and helped them polish their professional skills. Just as valuable, however, was the museum's staff's exposure to the Youth Insights program. Now, Youth Insights participants are sought after for internships in every department of the museum.

Today, Vidal says, "Youth Insights participants have become junior colleagues. During program planning meetings, education staff will suggest how to involve them in what we do, from programs for students and educators, to distance-learning programs and Web sites." Youth Insights has been the catalyst for new initiatives, including middle- and high-school junior docent programs and also has stimulated the staff's thinking about how to broaden the museum's community scope. The teens have been so effective in off-site programs that they model the kind of interaction the museum would like to bring to future relationships, such as partnerships with housing projects and community centers in targeted New York City neighborhoods. "It takes time to transform and educate an institution," Vidal says, ". . . but the program is much more broadly felt."

COMMUNITY CONNECTIONS

Since the beginning, community alliances have been an important mechanism for recruiting students and clients for Youth Insights programs. Five community partners have been actively involved:

◆ The Hetrick-Martin Institute, a nonprofit organization that serves lesbian, gay, and bisexual youth and their families and operates the Harvey Milk School

◆ Walt Whitman Junior High School in Brooklyn, where many students are recent immigrants and teachers are committed to supporting their development

◆ Regent Family Residence, a temporary housing facility for formerly homeless families

◆ United Neighborhood Houses (UNH), an umbrella organization for 37 settlement houses with active programs for senior citizens

◆ Dorot, Inc., a multiservice agency for homebound and homeless seniors

Other partners have included New York City public schools, the Police Athletic League, and the Boys Club of America. Key staff from these organizations form the Youth Insights Community Advisory Committee, which meets semi-annually with education department staff.

Building and maintaining these relationships has been a challenge, mostly because of staff turnover at the community centers and at the Whitney. The museum now looks for reciprocal, co-created partnerships, which are invariably the most successful. Recently, for example, the museum has worked to strengthen its relationship with Stanley M. Isaacs Neighborhood Center, a UNH community center in East Harlem that provides programming for young children, families, seniors, and teens. Whitney educators from various programs areas work closely with the community center staff to inform their constituencies about Whitney programs, develop collaborative programming, and assist in the Youth Insights recruitment process.

LOOKING TO THE FUTURE

After Sept. 11, 2001, a decline in attendance and financial support forced difficult budget decisions at the Whitney, but Youth Insights sustained only a small decrease in the number of participants. Building expansion plans are on hold, and the museum has undergone changes in board and staff leadership. Still, the program enjoys enthusiastic support throughout the museum from the board, curatorial staff, and senior management. As the museum assesses its future needs, one of its challenges is how to expand its community scope. Youth Insights represents a model and a starting point for building organizational relationships and for reaching and affecting individuals. "All museums are by definition educational institutions, institutions that bring together audiences with works of art and artifacts," says Director Adam Weinberg. "The Whitney's Youth Insights program represents the best of that complex, transactional process whereby the participants are simultaneously students, facilitators, mentors, and teachers."

With Youth Insights, the Whitney has a powerful effect on what most would consider small numbers of people. However, through the work of this group of talented and dedicated high school students, thousands of teens, families, and senior citizens have had a more profound and meaningful experience with art and culture. The program has also had a dramatic effect on the museum's visitor focus. Instead of isolating many of its programs for teens, families, and seniors, the museum now merges. "The energy that comes from this mix is extraordinary and helps us to revaluate the traditional divisibility of audiences by age and type," Weinberg says.

"We've been able to transform the way we think about every program we create," Vidal adds. Intergenerational learning "infuses all of our conversations, and while we don't have a sign out front that says 'intergenerational programs inside,' it is at the forefront of our minds."

Youth Insights Reunion, January 2003. During the program's six-year history, say staff, Youth Insights participants have become "junior colleagues" and have stimulated thinking about how to broaden the museum's scope. Photo by Quyen Tran. ©Whitney Museum of American Art, New York.

Transformative Moments

Coming together at an annual forum in 2001, staff from the 11 art museums whose stories are told in this book had a lively discussion about Malcolm Gladwell's *The Tipping Point*. Gladwell's theory that major change often happens suddenly and unexpectedly, driven by small events, seemed to describe some of the experiences these professionals had as they shaped and guided new visitor-focused initiatives.

Patterson Williams talked about concentrating resources in a long-term investment in staff at the Denver Art Museum. Marilyn Russell mentioned the dramatic differences at the Carnegie Museum of Art, the result of a confluence of small and not particularly calculated changes. At the Whitney Museum of American Art, said Cathleen Lewis, the Youth Insights program finally had generated excitement and credibility among museum staff.

By the end of The Pew Program for Art Museums and Communities, an abundance of tipping points was evident in all 11 museums. Others were still on the horizon, and some eventually proved unattainable. As Gladwell suggests, we can't assume that "the way we function and communicate and process information is straightforward and transparent. It is not. It is messy and opaque." Meaningful change indeed requires us to "reframe the way we think about the world."

Through their values, practices, and community relationships, these 11 museums are reframing the way they think about their purposes and their place in community life as well as their own internal worlds. In doing so, they're part of a thriving conversation that has been taking place in American museums over the past decade. In the intensive learning laboratories of the Program for Art Museums and Communities, the conversation was enriched by the availability of time, funding, and productive dialogue with colleagues from other museums.

Finding a vocabulary for the culture change that resulted—an intensely inter-personal and qualitative process—almost seems to diminish its significance. The effects were widespread, touching the museums, the public they serve, and the individuals involved in the project.

Two project directors explain how they are beginning to reframe the way they think about the world:

◆ Patterson Williams, Denver Art Museum: "If art itself draws on deep aspects of human psychology, then shouldn't art museums be more emotional, warmer, more embracing, more stimulating—and aren't they too academic, too cool, too stuffy, too unkind? Working with and for families became an opportunity to move along the spectrum from cool to warm, from unkind to embracing—and this was powerfully rewarding professionally."

◆ David Henry, Museum of Art, Rhode Island School of Design: "I was able to see the transformation of people as they saw the power of art in their lives. I was able to see the transformation of artists and their artistic practices as they saw first-hand the impact of their art on a wide range of people. And I was able to see the transformation of my museum colleagues as they saw that artistic projects driven by community concerns did not have to be compromised artistically."

Some of the most profound lessons these museums learned were simple ones: MUSEUMS NEED CREATIVE CULTURES. Risk and experimentation have not tra-ditionally been part of the museum culture, so failure can be unsettling. But the most creative ideas are often counterintuitive ones, and they require a working environment where people are encouraged—even expected—to chal-lenge assumptions, test possibilities, and learn from strategies that don't work. An atmosphere of open communication and risk taking marked some of the most dynamic and successful projects. As Sarah Schultz of the Walker Art Center says, "The projects instilled in the staff a deep understanding of the importance and rewards of listening, being flexible and truly collaborating—with audiences, partner organizations, artists, and colleagues alike."

AN INVESTMENT IN STAFF PAYS DIVIDENDS. Museums need to nourish their staffs' capabilities, support their passion for what they do, and stimulate con-tinuous learning. In the museum workplace, the tradition of service can lead

to an attitude of self-sacrifice that stifles innovation. Empowering staff begins at the board level with recognition of how valuable an asset the staff is. Leadership is essential for long-term success.

CHANGING AN INSTITUTION REQUIRES PATIENCE. Malcolm Gladwell has it right: Generating and implementing ideas require a willingness to accept the indirect, opaque progression of change. Balancing art and audience remains a challenge for these museums and others. Change requires time, especially when it affects a museum's culture, values, and external relationships. Mistakes will occur, but as long as there is a commitment to learning from them, change can be productive.

MUSEUM PROFESSIONALS ARE EAGER FOR REFLECTIVE CONVERSATION AND GENERATIVE THINKING. At the Pew program's annual forums, project directors, staff, and often museum directors had the opportunity for conversations that were different from those they might have at other professional gatherings. In assignments before each meeting, they produced honest assessments of the year's progress and problems. Around the table, there was frank discussion of issues, ideas, and practical solutions, often activated by pre-meeting reading. All of the participants came to realize that success and failures have many names, and that learning from failure is a form of success.

Along with institutional change, there was individual change and profession-al enrichment. Peggy Burchenal speaks for all the Pew project directors when she recalls the opportunity for "some of the most useful professional conver-sations I have ever had. I gained a network of talented colleagues, a sense of shared mission, and renewed faith in the many ways museum can in fact make a difference in the lives of people in their communities."

The museums' rewards have been cumulative, and the outcomes were not always easily measured. They are all attending to the same core ideal: becoming forums in their communities for engagement with art, aesthetics, and creativity. As they inspire their audiences to discover and explore, they are committed to the quality and intimacy of experiences people can have with art and artists.

Program for Art Museums and Communities Participants

Looking at Art Together: Families and Lifelong Learning, 1998–2002
www.artic.edu

Museum director
James N. Wood, Director and President

Project director
Jean Sousa, Director, Interpretive Exhibitions and Family Programs

Resources
Kids & Families Web page: www.artic.edu/aic/kids/index.html

Looking at Art Together: A Parent Guide to the Art Institute of Chicago (2002).
Ideas for a successful visit to the Art Institute, including age-specific tips,
games, sample tours, and at-home activities.

Looking at Art Together: Families and Lifelong Learning—Process Catalogue
(2002). For museum professionals, step-by-step documentation of the proj-
ect and observations on developing successful family programming

Mission
The purposes for which The Art Institute of Chicago is formed are: to found,
build, maintain, and operate museums, schools, libraries of art and theatres; to
provide support facilities in connection therewith; to conduct appropriate activ-
ities conducive to the artistic development of the region; and to conduct and
participate in appropriate activities of national and international significance;

To form, conserve, research, publish, and exhibit a permanent collection of
objects of art of all kinds; to present temporary exhibitions including loaned
objects of art of all kinds; and to cultivate and extend the arts by appropriate
means;

To establish and conduct comprehensive programs of education, including preparation of visual artists, teachers of art and designers; to provide education services in written, spoken, and media formats;

To provide lectures, instructions, and entertainment, including dramatic, film, and musical performances of all kinds, which complement and further the general purposes of the Institute;

To receive in trust property of all kinds and to exercise all necessary powers as trustee for such trust estates whose objects are related to the furtherance of the general purposes of the Institute or for all the establishment or maintenance of works of art (1982).

For more information
Jean Sousa, jsousa@artic.edu

CARNEGIE MUSEUM OF ART

Audience Research and Educational Initiatives, 1995–98
www.cmoa.org

Museum director
Richard Armstrong, Henry J. Heinz II Director

Project director
Marilyn M. Russell, Curator of Education

Resources
Teenie Harris Archive Project: www.cmoa.org/teenie. Part of the museum's expanded community focus; invites the public to help identify images in this significant collection of photographs of the Pittsburgh African-American community.

Teens and Contemporary Art: The 1999 Carnegie International. Video produced by teens.

Mission
Strategic Vision: As the preeminent venue for the presentation, collection, preservation, and interpretation of exceptional works of art, Carnegie Museum of Art aspires to enrich the imaginative and intellectual life of area

residents and visitors, attract the attention of national and international audiences, and significantly contribute to the cultural vibrancy of western Pennsylvania (2003).

Compare with: Carnegie Museum of Art will present and collect exceptional works of art for the enjoyment and enlightenment of all. The museum is an object holder and, at present, an interpreter. It will become a cultural shaper, It will educate and entertain repeat visitors, mostly from Pittsburgh and the tri-state region. It will strive to engage all visitors. Within the community it will remain a leader and become more conspicuous. Its board will review the work of staff and offer financial support and counsel. The museum will be a partner within Carnegie Institute, and seek long-range stability through increased endowments (1998).

For more information
Marilyn M. Russell, russellm@carnegiemuseums.org

<div align="right">

DENVER ART MUSEUM

</div>

World Art and Cultures, 1997–2001
www.denverartmuseum.org

Museum director
Lewis Sharp, Director

Project directors
Patterson Williams, Co-Dean of Education and Master Teacher for Asian and Textile Art
Melora McDermott-Lewis, Co-Dean of Education and Master Teacher for European and American Art

Resources
Families & Art Museums (2003). Nine online reports describing the museum's efforts to develop and refine programs for families. Available at: www.denverartmuseum.org; go to Family Fun section and click on "Resources for Museum Professionals."

Wackykids.org. A Web site where 8- to 10-year-olds can explore objects from the diverse cultures in the collection, print out art projects to do on their own, and find art-related resources.

Mission

Five-Year Vision Statement: While our commitment to our core mission remains unchanged, we will interpret this mission with the following guiding principle and key attributes as we move forward over the next five years. The guiding principle is: To create the most meaningful visitor experiences connected to art for a variety of audiences (2003).

Mission Statement: The Denver Art Museum (DAM) is a public, non-profit, educational resource for Colorado. The mission of the museum is to enrich the lives of Colorado and Rocky Mountain residents through the acquisition, preservation, and presentation of art works in both the permanent collections and temporary exhibitions, and by supporting these works with exemplary educational and scholarly programs (1986).

For more information
Maria Garcia, Head of Family Programs, mgarcia@denverartmuseum.org

ISABELLA STEWART GARDNER MUSEUM

The Eye of the Beholder, 1996–2000
www.gardnermuseum.org

Museum director
Anne Hawley, Norma Jean Calderwood Director

Project directors
Margaret K. Burchenal, Curator of Education and Public Programs
Kären Croff Bates, Curator of Education (until 1999)

Resources
The Eye of the Beholder: Contemporary Artists and the Public at the Isabella Stewart Gardner Museum (2000). Outlines the growth of the museum's artist-in-residence and school partnership programs from 1996–2000 and focuses on the questions and challenges that guide future work. Available at: www.gardnermuseum.org/education/eyeofthebeholder.html.

Learn@Isabella Stewart Gardner Museum: www.gardnermuseum.org/education/gardner.html. The museum's education Web site.

Artists-in-residence

Nancy Slonim Aronie, writer

Joan Bankemper, garden and installation artist

Paul Beatty, writer

Ashley Bryan, storyteller and children's book illustrator

Ambreen Butt, painter

Edwidge Danticat, writer

Heide Fasnacht, sculptor

Vadim Fishkin, conceptual visual artist

Kenneth Frazelle, composer

Mona Higuchi, installation artist

Abdullah Ibrahim, jazz composer and musician

Ann Lauterbach, poet

Josiah McElheny, glassblower

Todd McKie, painter

Walter Mayes, storyteller

Lee Mingwei, installation and performance artist

Abelardo Morell, photographer

Jay O'Callahan, storyteller

Laura Owens, painter

Olivia Parker, photographer

Jennifer Tipton, mosaic artist

Jessica Yu, filmmaker

Mission

Isabella Stewart Gardner founded her museum in 1903 for the "education and enjoyment of the public forever." Today, the museum exercises cultural and civic leadership by nurturing a new generation of talent in the arts and humanities; by delivering the works of creators and performers to the public; and by reaching out to involve and serve its community. The collection is at the center of this effort as an inspiring encounter with beauty and art. (2000)

For more information

Margaret K. Burchenal, pburchenal@isgm.org

Minneapolis Institute of Arts

A New Audience for a New Century, 1995–97
www.artsmia.org

Museum director
Evan M. Maurer, Director and CEO

Project director
Kathryn C. Johnson, Chair, Education Division

Resources
A New Audience for a New Century (1998). Documents the process, findings, and conclusions of the museum's audience research project. Available at: www.artsmia.org/new_audience.pdf.

Online teaching and learning resources: www.artsmia.org/interactive-media/online-resources.cfm.

ArtsConnectEd: www.artsconnected.org. Gateway to arts education resources, a partnership of the museum and the Walker Art Center.

Mission
The Minneapolis Institute of Arts is dedicated to national leadership in bringing arts and people together to discover, enjoy, and understand the world's diverse artistic heritage (1992).

For more information
Kathryn C. Johnson, kjohnson@artsmia.org

Museum of Art, Rhode Island School of Design

Art ConText, 1998–2002
www.risdmuseum.org

Museum director
Phillip Johnston, Director (until 2003)
Lora Urbanelli, Interim Director

Project director
David Henry, Head of Museum Education

Resources
Art ConText Web site: www.risd.edu/artcontext. An interactive documentary archive of the project, including an interview with each artist-in-residence.

Art ConText: People Seeing Themselves, Seeing Each Other (2002). A limited number of copies of this project video are available from dhenry@risd.edu.

Artists-in-residence
Shimon Attie, photographer, video artist
Jerry Beck, installation artist and community activist
Rebecca Belmore, mixed media
Barnaby Evans, installation artist
Wendy Ewald, photographer, video artist
Hachivi Edgar Heap of Birds, painter, public artist
Indira Freitas Johnson, ceramist, mixed media
David McGee, painter
Pepón Osorio, installation artist
Ernesto Pujol, photographer, installation artist
Lynne Yamamoto, installation artist

Mission
The RISD Museum of Art exists to bring people and works of art together.

Distinguished by its relationship to the Rhode Island School of Design, the Museum is a vital cultural resource that educates and inspires artists, designers and the general public. The Museum's mission is to inspire through innovative programs and exhibitions that challenge viewers' assumptions about visual expression and gives them new insight into the human experience.

The Museum is dedicated to the acquisition, preservation, presentation, and interpretation of works of art and design representing diverse cultures and ranging from ancient times to the present (2004).

Former mission:
To instruct artisans in drawing, painting, modeling, designing so that they may apply the principles of Art to the requirements of trade and manufacture; to train students in the practice of Art that they may give instruction to

others, or become artists themselves; to support the general advancement of public Art Education, by the exhibition of works of Art and of Art school studies, and by lectures on Art (1877, in use until 1998).

For more information
David Henry, dhenry@risd.edu

MUSEUM OF CONTEMPORARY ART SAN DIEGO

Arte/Comunidad (Art/Community), 1995-1999
www.mcasd.org

Museum director
Hugh M. Davies, David C. Copley Director

Project directors
Kelly McKinley, Education Curator (2000–2002)
Seonaid McArthur, Education Curator (1992–1999)

Resources
Discover Contemporary Art: A free bilingual family guide for visitors (out of print)

Garden Gallery Guide: A free bilingual family guide for visitors

Arts Partnership Program Web site: www.mcasd.org/education_programs/outreach.asp

Artists-in-residence
Celia Alvarez Muñoz, installation, mixed media
José Bedia, installation, mixed media
Leonardo Drew, sculpture
Marcos Ramirez ERRE, installation, mixed media
Silvia Gruner, installation, mixed media
Geoffrey James, photography
Roman de Salvo, installation, mixed media
Kenny Scharf, painting
Regina Silveira, painting, installation
Gary Simmons, painting, installation

Mission
The Museum of Contemporary Art San Diego functions as an art museum collecting, preserving, presenting, and interpreting the art of our time; a cultural center and forum for the exploration of contemporary art and ideas; and a research laboratory for artists and audiences. It serves a diverse constituency in the binational San Diego/Tijuana region as well as visitors from around the world (1998).

For more information
Anne Farrell, Director of External Affairs, afarrell@mcasd.org

SEATTLE ART MUSEUM

Growing Up with Art, 1996–2000
www.seattleartmuseum.org

Museum director
Mimi Gardner Gates, Illsley Ball Nordstrom Director

Project director
Jill Rullkoetter, Kayla Skinner Director of Education and Public Programs

Resources
Ann P. Wyckoff Teacher Resource Center: www.seattleartmuseum.org/teach/TRC. Online access to a searchable catalogue of resources for educators.

Create Your Own Exhibition: A Project-Based Curriculum: A curriculum unit for grades 6–12 based on the Documents International series.

Teacher Lessons: www.seattleartmuseum.org/teach/schoolsteachers.asp. Free downloadable materials related to special exhibitions.

Learn Online: www.seattleartmuseum.org/teach/learnonline.asp. Art tours and interactive games, lesson plans, and art activities for teachers, students, and parents.

Artists-in-residence
Quincy Anderson, visual artist
Angie Bolton, dancer

Romson Bustillo, painter

Roger Fernandes, visual artist

Ron Hilbert, painter

Maggie Mackin, visual artist

Paramasivam, sculptor

Won Ldy Paye, storyteller

Annie Penta, musician and dancer

Hannah Salia, visual artist

Nathan Kumar Scott, puppeteer and theater artist

Ann Teplick, writer

Midori Kono Thiel, calligrapher, dancer, and musician

Richard Wallace, theater artist

Frederic Wong, visual artist

Peter Zekonis, visual artist

Student-curated exhibitions

Documents International series: "Reflections in the Mirror: A World of Identity" (1999), "Eleven Heads Are Better than One: Sixth-Graders Connect with SAM" (2000)

Mission

SAM provides a welcoming place for people to connect with art and to consider its relationship to their lives. SAM is one museum in three locations: Seattle Art Museum downtown, Seattle Asian Art Museum at Volunteer Park, and the Olympic Sculpture Park on the downtown waterfront. SAM collects and exhibits objects from across time and across cultures, exploring the dynamic connections between past and present (2002).

Compare with: Forward-looking and ambitious, the Seattle Art Museum is dedicated to engaging a broad public in an open dialogue about the visual arts by collecting, preserving, presenting, and interpreting works of art of the highest quality.

For more information

Jill Rullkoetter, jillr@seattleartmuseum.org

University of California, Berkeley Art Museum and Pacific Film Archive

The Time of Your Life: Enhancing Student Engagement with the Arts, 1998–2002
www.bampfa.berkeley.edu

Museum director
Kevin Consey, Director

Project director
Stephen Gong, Associate Director

Resources
Conversations: www.bampfa.berkeley.edu/conversations. Interactive Web page featuring video contributions from artists, scholars, students, and the community, including visitor feedback from the video conversations kiosk in the museum.

Cal Student Outreach Manual. A guide to the logistics and procedures of student-to-student outreach, including general guidelines applicable to other university museums. Available from BAM/PFA Student Advisory Committee.

Student Resources: www.bampfa.berkeley.edu/student_resources

Academic Resources: www.bampfa.berkeley.edu/faculty_resources

Artists-in-residence
Vincent Carelli, video artist and ethnographer
Donigan Cumming, video artist
Vitaly Komar and Alexander Melamid, conceptual artists
Kristin Lucas, video, performance, and installation artist
Leslie Thornton, film and video artist
Roland Freeman, photographer
Johan van der Keuken, documentary filmmaker
Dee Dee Halleck, videomaker
Fred Wilson, visual artist

Mission
To inspire the imagination and ignite critical dialogue through art and film. The Berkeley Art Museum and Pacific Film Archive is the visual arts center of the University of California, Berkeley. Through art and film programs, collec-

tions and research resources, we aspire to be locally connected, globally relevant, engaging audiences from the campus, community and beyond (2003).

For more information
Stephen Gong, sgong@berkeley.edu

WALKER ART CENTER

Artists and Communities at the Crossroads, 1998–2002
www.walkerart.org

Museum director
Kathy Halbreich, Director

Project director
Howard Oransky, Director of Planning
Sarah Schultz, Director of Education and Community Programs

Resources
learn.walkerart.org: Interactive Web site for the Walker's education and community programs, including links to programs for teens, kids and families, students and teachers, and Walker on Wheels

ArtsConnectEd: www.artsconnected.org. Gateway to arts education resources including access to over 15,000 works of art, a partnership of the Walker and the Minneapolis Institute of Arts.

Artists-in-residence
Film/video:
Craig Baldwin
Alan Berliner
Cheryl Dunye
Spencer Nakasako

Performing arts:
Mikhail Baryshnikov and White Oak Dance Project
Joanna Haigood and Zaccho Dance Theatre
Fred Ho, Paul Chan, and Scott Marshall
Bill T. Jones/Arnie Zane Dance Company

Liz Lerman Dance Exchange
Diane McIntyre and Lester Bowie
David Murray Octet and Urban Bush Women
Shirin Neshat
Salia ne Sedou
Roger Guenveur Smith

Visual arts:
Atelier van Lieshout
Glenn Ligon
Catherine Opie
Sarah Sze
Nari Ward

Mission

The Walker Art Center is a catalyst for the creative expression of artists and the active engagement of audiences. Focusing on the visual, performing, and media arts of our time, the Walker takes a global, multidisciplinary, and diverse approach to the creation, presentation, interpretation, collection, and preservation of art. Walker programs examine the questions that shape and inspire us as individuals, cultures, and communities (1993).

For more information

Howard Oransky, howard.oransky@walkerart.org
Sarah Schultz, sarah.schultz@walkerart.org

WHITNEY MUSEUM OF AMERICAN ART

Youth Insights: Building an Intergenerational Conversation on American Art and Culture, 1997–2001
www.whitneymuseum.org

Museum director

Maxwell Anderson, Director (until 2002)
Adam Weinberg, Director

Project directors

Helena Vidal, Assistant Director of Education

Tami Thompson, Coordinator, Youth Insights
Cathleen Lewis, Head of Youth and Community Programs (2001–2002)
Sandra D. Jackson, Head of School, Family, and Intergenerational Programs
(1998–2001)

Resources

Youth2Youth Web site: www.youth2youth.org. Interactive site designed by
Youth Insights teenagers. Includes participants' biographies and reflections,
artist interviews, and program information.

Mission

The Whitney Museum of American Art is the nation's preeminent institution
devoted to the collection, exhibition, and scholarly study of twentieth-centu-
ry and contemporary American art. The museum was established by Gertrude
Vanderbilt Whitney at a time when American art was seldom exhibited in
museums and held little interest for collectors. In 1931, the Whitney opened
its doors with a mandate to support living artists. Today, the collection has
grown to become the most comprehensive assembly of twentieth-century
American art in the world, consisting of more than 13,000 objects by more
than 1,900 artists.

The Whitney is the leading advocate for American art of our time. An essen-
tial forum for contemporary artists since its founding, the Whitney is com-
mitted to being authoritative in its research, innovative in its programs, and
collaborative in its spirit. Through its exhibitions and its educational pro-
gramming, the Museum engages a broad audience in the artistic and cultural
dialogues of the day, as it has since its beginnings. A commitment to the pres-
ent always involves taking risks. The Whitney embraces this role, and seeks to
honor its historic obligation to artists at work in America.

For more information
Helena Vidal, helena_vidal@whitney.org

The Authors

BONNIE PITMAN has been the deputy director of the Dallas Museum of Art since 2000 and served as project director for The Pew Charitable Trusts Program for Art Museums and Communities from 1993 to 2004. During her career, she has been actively involved in the museum field as an educator, curator, administrator. She has worked at the Bay Area Discovery Museum, University Art Museum and Pacific Film Archive at the University of California at Berkeley, Seattle Art Museum, New Orleans Museum of Art, Winnipeg Gallery in Canada, Lincoln Center for the Performing Arts in New York, National Endowment for the Arts, and National Endowment for the Humanities.

Ms. Pitman has played an active role in AAM and currently serves on the association's board of directors. She chaired both the committee that wrote the 1992 national report, *Excellence and Equity: Education and the Public Dimension of Museums* and the AAM Accreditation Commission and was a commission member for 12 years. Ms. Pitman's publications include *Museums, Magic and Children* (1981) and *Presence of Mind: Museums and the Spirit of Learning* (1999).

ELLEN HIRZY is an independent writer and editor who works with museums and cultural organizations. As a consultant to The Pew Charitable Trusts Program for Art Museums and Communities, she observed the experiences of the 11 participating museums over six years. Her work often relates to the evolution of museums' public role and involves documenting and writing about the results of group processes. She contributed to *Mastering Civic Engagement: A Challenge to Museums* (2002) and was the principal writer of *Excellence and Equity: Education and the Public Dimension of Museums* (1992) and *Museums for a New Century* (1984).

Index

A

Allen, Kathleen Peckham, 67, 68

animator panels, 40

architecture
 Art Institute of Chicago, 29
 Denver Art Museum, 118, 129
 Minneapolis Institute of Arts, 117
 *Museum of Art, Rhode Island
 School of Design,* 108
 *Museum of Contemporary Art
 San Diego,* 92, 97
 Walker Art Center, 44

Armstrong, Richard, 12, 52, 54,
 54–55, 57–58, 59, 61

Art ConText, 100, 106, 107–108

Art Institute of Chicago, 13, 19,
 22–30, 145–146
 mission, 145–146

Arte/Comunidad (Art/Community),
 90–94, 96

artist-in-residence programs, 11–12,
 19, 20
 *Berkeley Art Museum and Pacific
 Film Archive,* 78, 81, 83
 Isabella Stewart Gardner Museum,
 36–38, 39
 *Museum of Art, Rhode Island
 School of Design,* 102, 103,
 104–106
 *Museum of Contemporary Art San
 Diego,* 95–96
 Walker Art Center, 42, 44–50

artists, teachers and, 69

Artists and Communities at the
 Crossroads, 44–50

ArtsConnectEd, 115

Arts Partnership Program, 96–98

audience, 16–17
 *Berkeley Art Museum and Pacific
 Film Archive,* 85
 Carnegie Museum of Art, 55–56,
 60–61
 Denver Art Museum, 129
 *Museum of Contemporary Art
 San Diego,* 94–95
 new directions, 87–88
 research, 112–113
 students, 76, 78–80, 132

Axline, Lela and Rea, 99

B

backpacks, 122–123

Bankemper, Joan, 37, 38

Barajas, Olivia, 80

Batis, Linda, 59

Belmore, Rebecca, 100

Berkeley Art Museum and Pacific
 Film Archive, 13, 19, 20, 76–85,
 155–156
 expansion, 84–85
 mission, 155–156

Bill T. Jones/Arnie Zane Dance
 Company, 46

board, membership, 57, 98

Buffington, Lana, 80

Burchenal, Margaret (Peggy), 11, 39, 40–41, 143

C

Carelli, Vincent, 83

Carnegie International, 59

Carnegie Museum of Art, 20, 52–62, 146–147
mission, 146–147

Carr, David, 103

change, 15–17, 143
agenda, 17
resources for, 13

church, 47

civic role, 92–93

Cohen, Burt, 113, 116

collaboration. *See* partnerships

collections, 11

communication, 14, 24–28

community involvement, 2, 7, 8–9, 14, 15, 16, 143
Carnegie Museum of Art, 54–56
Museum of Art, Rhode Island School of Design, 100, 106
Museum of Contemporary Art San Diego, 90–98
Walker Art Center, 42, 44–50
Whitney Museum of American Art, 137–138

community liaison, 13, 60

community outreach coordinator, 98

Consey, Kevin, 84, 85

customer service, 113

D

dance, 46, 49

Davies, Hugh M., 90, 95, 98, 99

Davis, Jessica, 136

Denver Art Museum, 118–129, 147–148
audience, 88
mission, 148

discussion, museum professionals, 143

Donaldson, M. Wayne, 97

Dorot, Inc., 133, 138

Dun, Tan, 97

Dunye, Cheryl, 45–46

E

education, 60–61, 64–74
assessing, 67–70

engagement, collections and, 11

environment, creative, 12–14, 125–127, 142

Erbach, Mary, 26

ERRE, Marcos Ramfrez, 96

Eskridge, Robert W., 22, 24, 28

evaluation
Berkeley Art Museum and Pacific Film Archive, 78, 82
Seattle Art Museum, 67–70, 73–74
Whitney Museum of American Art, 135–136

Excellence and Equity: Education and the Public Dimension of Museums, 8

exhibitions, 59

experimentation, 14, 38, 58, 128–129

extroverted focus, 12

The Eye of the Beholder, 32, 34

F

faculty collaboration, 80–82

family focus, 19, 88
 Art Institute of Chicago, 22–30
 characteristics, 121–124
 Denver Art Museum, 118–129
 Minneapolis Institute of Arts,
 112–117
 Museum of Contemporary Art San
 Diego, 96
 rationale, 120–121
 Whitney Museum of American Art,
 133

Farrell, Anne, 92, 95

film and video, 45–46, 48, 83

focus, 82–83, 110, 112

Ford Motor Company, 115

Freeman, Roland, 81, 83

funding, 8, 16

G

Garcia, Maria, 122, 126, 127

Garza, Monica, 98–99

Gates, Mimi, 64, 70, 71

Gladwell, Malcolm, 141, 142

Gluckman, Richard, 97

Goldsworthy, Andy, 96, 97

Gong, Stephen, 14, 76, 78–79, 82, 83

Goodman, Sherry, 80, 81, 82

Graetz, Linda, 34, 35

graffiti, 96

Grancher, Valéry, 80

Graves, Michael, 117

Growing Up with Art, 66–74
 evaluation, 73–74

Gumbert, Marcia, 58

H

Halbreich, Kathy, 42, 44, 46–47

Hammel, Green, and Abrahamson, 44

Harding, Beverly, 69–70

Harris, Teenie, 61–62

Hawley, Anne, 11, 32, 34, 39–40

Henry, David, 100, 102, 103, 106,
 107, 142

Herzog & de Meuron, 44

Hetrick-Martin Institute, 137

Ho, Fred, 49

Hudson, Robert, 25

I

image. *See* perception

Institute of Museum and Library
 Services, 115

Isabella Stewart Gardner Museum, 7,
 17, 32–41, 148–149
 mission, 149

J

Jacobs, Lucia, 80, 81

Johnson, Indira Freitas, 105

Johnson, Josie R., 112

Johnson, Kathryn (Kate), 14, 112,
 114, 115, 116–117

Jones, Bill T., 46

K

Keyo, Pat, 37–38
Komar, Vitaly, 81

L

La Jolla Museum of Contemporary
 Art. *See* Museum of
 Contemporary Art San Diego
Lampkins-Fielder, Raina, 130
leadership, 39–40, 98–99, 125–126
lesson plans, 67, 68–69
Lewis, Cathleen, 132, 135, 141
Libeskind, Daniel, 129
libraries, 87
 Art Institute of Chicago, 29
 Carnegie Museum of Art, 61
 Denver Art Museum, 120,
 123–124, 127–128
 Minneapolis Institute of Arts, 115
 *Museum of Art, Rhode Island
 School of Design,* 100, 102–104
 *Museum of Contemporary Art San
 Diego,* 97
 Seattle Art Museum, 72
Looking at Art Together, 20–29

M

marketing, 56–58, 113–114
Maurer, Evan M., 110, 115–116
McDermott-Lewis, Melora, 120, 121,
 122, 124, 125, 126
McGee, David Wayne, 104–105
McKinley, Kelly, 97, 98–99

McNamee, Gillian, 27
Melamid, Alexander, 82
Mingwei, Lee, 36, 37
Minneapolis Institute of Arts, 14,
 110–117, 150
 audience, 88
 mission, 150
mission, 16, 141
 Art Institute of Chicago, 145–146
 *Berkeley Art Museum and Pacific
 Film Archive,* 155–156
 Carnegie Museum of Art, 146–147
 Denver Art Museum, 148
 Isabella Stewart Gardner Museum,
 149
 Minneapolis Institute of Arts, 150
 *Museum of Art, Rhode Island
 School of Design,* 108, 151–152
 *Museum of Contemporary Art
 San Diego,* 153
 Seattle Art Museum, 74, 154
 Walker Art Center, 157
 Whitney Museum of American Art,
 158
Mitchell, Michael, 25–26
mobile art center, 48
Moneo, José Rafael, 108
museum environment, new, 7–17
Museum of Art, Rhode Island School
 of Design, 100–108, 150–152
 audience, 87
 future, 107–108
 mission, 151–152
Museum of Contemporary Art San
 Diego, 90–99, 152–153
 audience, 87
 mission, 153
music, 97

N

Nakasako, Spencer, 48

National Task Force on Museum
 Education, 1–2

A New Audience for a New Century,
 112–115
 long-term effects, 115–117

Newman, Alan, 55–56

O

Oransky, Howard, 45, 49, 50

Osorio, Pepón, 108

outreach, 74

P

Parent Workshops, 24, 27

partnerships, 15, 87
 Art Institute of Chicago, 28–29
 *Berkeley Art Museum and Pacific
 Film Archive,* 80–82
 Carnegie Museum of Art, 58, 61,
 64, 66, 72
 Denver Art Museum, 120, 127–128
 Isabella Stewart Gardner Museum,
 34–36, 39
 Minneapolis Institute of Arts, 115
 *Museum of Art, Rhode Island
 School of Design,* 100, 102–104
 *Museum of Contemporary Art San
 Diego,* 96–98
 Walker Art Center, 47–48
 Whitney Museum of Art, 133,
 137–138

perception, 20, 55–56, 93, 94, 134

Pew Charitable Trusts, The, 1, 2–3, 8

Pfeil, Anne, 69

Piano, Renzo, 29

planning process, 40

Pollard, Deborah Starling, 60, 62

Porter, Ron, 55–56

Program for Art Museums and
 Communities (PAMC), 1, 2–4, 8
 design, 3
 participants, 9–10

programs and activities, 16, 19, 20
 Carnegie Museum of Art, 54, 56
 Denver Art Museum, 121–124, 128
 *Museum of Contemporary Art
 San Diego,* 93

public participation. *See*
 community involvement

Pujol, Ernesto, 107, 108

purpose, 141–142

Putnam, Robert, 110

R

Rachleff, Peter, 47

readiness factor, 54–55

Regent Residence, 133–134, 137

relationship building, 76

resources, 16

Rinehart, Richard, 80

Rullkoetter, Jill, 66–67, 68, 72, 73, 74

Russell, Marilyn, 54, 58, 59, 60, 141

S

Scharaf, Kenny, 96

schools
Carnegie Museum of Art, 61
Isabella Stewart Gardner Museum,
34–36
Seattle Art Museum, 64, 66
Whitney Museum of American Art,
137

Schultz, Sarah, 11–12, 44–45, 49, 50

sculpture, 46, 96

Seattle Art Museum, 13, 20, 64–74,
153–154
mission, 154

Sekhr-Ra, Akhmiri, 47

services, 20

Sharp, Lewis, 118, 125, 129

Simmons, Gary, 96

Smith, W. Eugene, 52

Sousa, Jean, 25, 29

space, 16

staff, 13, 16
*Berkeley Art Museum and Pacific
Film Archive,* 76, 83
Carnegie Museum of Art, 54, 58–59
cross-departmental teams, 54,
58–59
curators, 74
Denver Art Museum, 120,
126–127, 128
investment in, 142–143
Minneapolis Institute of Arts, 114
*Museum of Contemporary Art
San Diego,* 98
Seattle Art Museum, 66, 74
teacher involvement, 66

Standring, Timothy, 126

Stanford, John, 64

store-front galleries, 93

structured listening, 124–125

student-curated exhibitions, 70–71

students
audience, 76–85, 130–139
tour guides, 78, 79–80

surveys, 57, 115, 116

T

teachers
faculty collaboration, 82–83
tools for, 72–73
training, 108

team building, 14

technology, interactive, 12, 16

Tedeschi, Martha, 26

Thompson, Dale, 102

Tipping Point, The, 141

tour guides, student, 78, 79–80

training
customer service, 113
teachers, 108
youth, 132

U

United Neighborhood Houses, 133,
138

University of California, Berkeley
Art Museum and Pacific Film
Archive. *See* Berkeley Art
Museum and Pacific Film Archive

Urbanelli, Lora, 106

V

van Lieshout, Joep, 48

van Parys, Johan, 47

Vidal, Helena, 134, 137, 139

video. *See* film and video

vision. *See* mission

visitors
 experience, 16
 -focused center, 10–12
 surveys, 57, 115, 116

W

Walker Art Center, 7, 19, 42–50,
 115, 156–157
 evaluation, 48–50
 mission, 157

Walker on Wheels, 47

Wallace Foundation, 71, 74

Ward, Nari, 46

Weinberg, Adam, 132, 138, 139

Wepsic, Elizabeth, 96

Whitney Museum of American Art,
 130–138, 157–158
 audience, 88
 future, 138–139
 mission, 158

Wilkinson, Jim, 56

Williams, Patterson, 120, 121, 123,
 125, 126, 129, 141, 142

Wilson, Fred, 81

Wood, James N., 24, 29–30

Worlds of Wonder, 104

Y

Youth Insights, 130–139
 impact, 135–137